T0303771

GATES OF THE CITY OF LONDON

ALAN BROOKE

AMBERLEY

First published 2022

Amberley Publishing, The Hill, Stroud
Gloucestershire GL5 4EP

www.amberley-books.com

British Library Cataloguing in Publication Data.
A catalogue record for this book is available from the British Library.

ISBN 978 1 3981 0261 3 (print)
ISBN 978 1 3981 0262 0 (ebook)

Typesetting by SJmagic DESIGN SERVICES, India.
Printed in Great Britain.

Contents

Introduction

The names of the old City gates – Aldgate, Aldersgate, Bishopsgate, Cripplegate, Ludgate, Moorgate and Newgate – are familiar to us as parts of the City of London that still bear their names. Like the wall that enclosed them, they provided continuity in the City's history from around AD 200 to the eighteenth century when the gates were dismantled and eventually demolished. The gates were part of a complex of towers, defensive ditches and bastions that formed the ancient Roman wall (Moorgate came later). Most of the main gateways were aligned with the network of Roman roads. We do not know what the Romans called these gates, so we refer to them by their medieval names. Nothing remains of the seven gates and only plaques bear testimony to their location.

Over the centuries the gates fell into poor shape and were frequently repaired, replaced or extended on or near their ancient foundations. In addition to the main gates, smaller gates, or posterns, for pedestrians were also built. Prompted by raids from Saxon pirates in the third century, construction of a riverside wall began around AD 280. However, this wall was long gone by the twelfth century. The riverside stretch of the City had a number of water gates, mainly landing places for the use of traders. As the City expanded, its boundaries were marked by a number of bars. The familiar heraldic dragons now designate the boundaries of the City.

The wall of the Roman city, Londinium, stretched over 2 miles in length from Tower Hill in the east to Blackfriars in the west. The wall was built of ragstone, a hard, sedimentary rock extracted from Maidstone in Kent, and brought to London by boat on the Thames. Gateways were constructed at north, east and west points of entry and an external ditch reinforced the defensive system. The City wall was one of the largest building projects undertaken in Roman Britain, and its course remained relatively unchanged for some 1,500 years, unlike many Continental towns and cities in the Middle Ages. During the Great Fire of 1666 the wall stopped the fire spreading further.

After the Roman withdrawal from Britain around AD 410, we have fewer records of London. London experienced occupations and raids from Saxons, Danes and Vikings. The next historical mention of the Roman wall appears

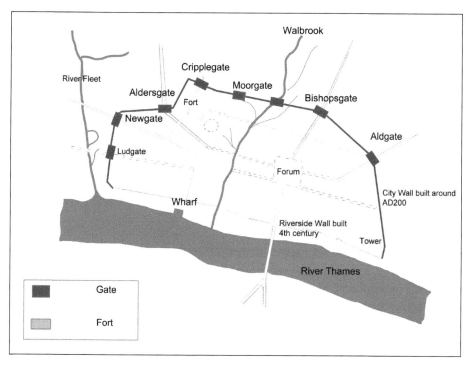

London Wall and gates.

in the *Anglo-Saxon Chronicle*, when Alfred the Great drove the Danes from London (AD 871–72) and ordered the restoration of the City and its defences.

The original wall consisted of Newgate, Ludgate, Aldgate, Cripplegate and Bishopsgate. At the north-west corner, the wall included a large 12-acre fort. Aldersgate was eventually added, perhaps to replace the west gate of the fort. Moorgate was expanded from a postern into a larger gate in the early fifteenth century.

The City of London, as defined by its boundaries, developed a unique form of government with its constitution rooted in the ancient rights and privileges before the Norman Conquest. Then, as now, the City was the focus of financial and commercial business. Local government was complex (and still is). In Saxon and medieval London, municipal authority rested with aldermen, the supreme court of the medieval City, with administrative and judicial functions. Around 1189, the City gained the right to have its own mayor.

The duty to maintain and control the various assizes, such as the Assize of Nuisance and Building, rested with the mayor, sheriffs and Common Council. They also had the duty to accurately measure goods brought into or taken out of the City, either by the Port of London or by road. Various committees and bodies were established to maintain and take responsibility for the running of the City such as the Committee for Letting the City Lands, whose responsibility was the care of the gates.

Protection of the medieval City of London and its people largely depended upon the condition of the wall and gates. Maintenance of the wall came from a tax called

'murage', raised by levying certain customs on goods coming into the City and collected at the gates. However, as David Whipp states, it is 'impossible to make any assessment of the importance of the city gates as arteries of supply and trade'.

In the medieval period the fortified towers of the gates had a military look with crenellated roofs and gaps or indentations at intervals to allow for the launch of arrows or other projectiles. They also had storage space for weaponry and accommodation, mainly for watchmen, although later it was used for City officials. Prisons were also a feature of some of the gates. A portcullis would normally be between the towers, which was lowered at night but also acted as a means of controlling access to the City in the day. Images of the gates from the late seventeenth century show them unhinged with their portcullises open, thus rendering them pointless for defensive purposes.

The gates played an important function in controlling trade, regulating access, representing the prestige of the City, defence and collecting taxes. In addition to the daily flow of traffic there were processions, curfews and occasional rebellions. The gates also displayed public information, including announcements, tax and toll schedules, and legal texts, as well as the gruesome body parts of recently executed felons, which were intended to serve as a warning to potential transgressors. A gate could be heavily fortified and ornamented with heraldic shields, inscriptions or statues of saints and monarchs. They were also places of commerce, as the late sixteenth-century poet Isabella Whitney commented in 'The Manner of Her Will': 'To every gate under the walls, that compass thee about, fruitwives leave to entertain, such as come in and out.'

The City authorities appointed sworn keepers to the gates, who were responsible for opening and closing them. Keepers were tasked with preventing lepers into the City, collecting tolls and watching out for potential trouble. At times of threat the guards would muster around twenty-four armed men to the gate. In response to the Peasants' Revolt of 1381, the authorities increased the quota of men to fifty per gate. In addition, residents would be expected to defend the City if circumstances demanded. At night a curfew was imposed and the City gates were closed at 8 p.m. until sunrise. Ordinances were issued stating that men of the watch were to be armed at all hours at the gate 'to answer to any persons on horses or with arms entering the city'.

The gates of the medieval City witnessed an increasingly crowded environment, with horses, carts, wagons, livestock, noise and people jostling for space. Roads were narrow, uneven and usually in poor condition. Added to this was the perennial problem of traffic congestion and accidents. The authorities had to deal with the never-ending task of regulating markets, the extension of buildings and cleansing the streets, especially the amount of animal droppings from livestock coming in and out of the City. The flow of traffic in the fifteenth century prompted the City authorities to issue an ordinance restricting carts from speeding.

Livestock provided food, traction power, wool and dairy produce. Over the centuries, routes to the City from the north, east and west would have seen this

type of trade on its way to busy markets, such as Smithfield. By 1600 suburban developments and a population of almost 200,000 had already breached the City wall in places. In the seventeenth century hackney coaches clattered to and fro and sedan chairs navigated their way around pedestrians and narrow lanes. No wonder that the eighteenth century heralded widespread changes.

As London continued to expand, the wall and gates outlived their defensive function and were becoming an obstruction to the increasing volume of traffic. The Committee for Letting the City Lands dealt with many complaints regarding the encroachment of buildings and gardens on the gates or the wall. Emily Mann (*Architectural History*, 2006) quotes from the Court of Aldermen in 1674, which clearly showed how the authorities viewed the gates when addressing the issue of a building threatening to obscure part of the gate at Aldgate: '... conceiving that by the ancient custom of this City the gates thereof, which built for ornament as well as service, ought to remain clear and free from all obstructions by building or otherwise'. 'Built for ornament' emphasises the symbolic significance placed upon the gates, as well as the sense of civic pride.

By the mid-eighteenth century, London's population was estimated to be 750,000. This brought an accompanying expansion of housing, public facilities and traffic. Parliament enacted building legislation and initiated important infrastructure projects. During the 1760s several paving Acts were passed, which

Car park entrance near the Museum of London with a London Wall Walk information board. (© Museum of London)

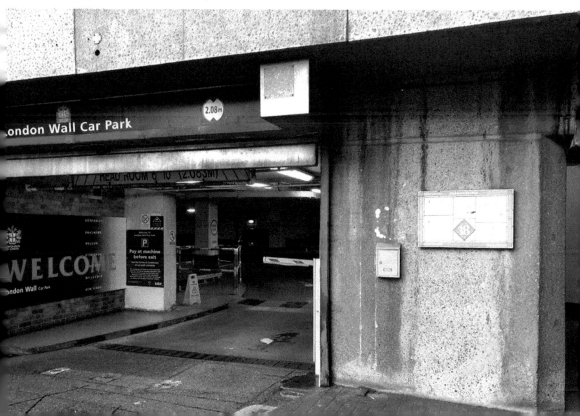

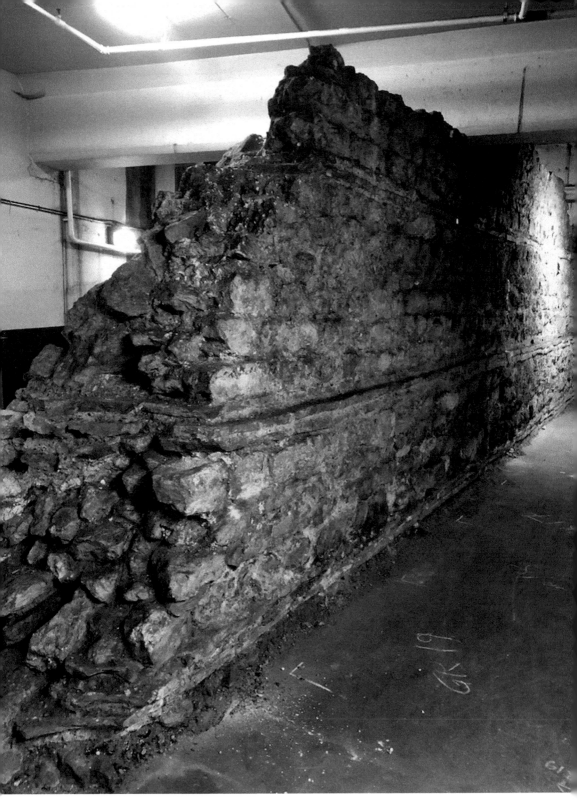

Part of London Wall in the car park (Bay 52) next to the Museum of London.

helped to keep local trade flowing. Regular street cleaning was implemented to ensure a clear passageway for traffic. In May 1760, an Act provided for 'widening, certain streets, lanes, and passages within the City of London and for the opening of certain new streets and ways'. Improvements brought about by the street Acts were dramatic. The gates, which had been a defining part of the City's history for centuries, were now deemed a hindrance and finally removed.

Although a large part of the wall was demolished in 1760, remains of it can still be seen, while other parts are incorporated into car parks, churches and other buildings. For anyone wishing to walk the route of the London Wall, there are useful and informative guides, including twenty-one information boards along the London Wall Walk. Parts of the wall can be clearly seen near the Tower of London and the area around and near the Museum of London.

The main section of this book focuses on the seven historic gates that were part of the City wall. A further section includes some of the smaller gateways or posterns, bars (the best example of which is Temple Bar) and water gates, which served mainly as landing places. Also included is what John Stow, in his *Survey of London* (1598), referred to as 'Bridge Gate'. Located at the entrance to the

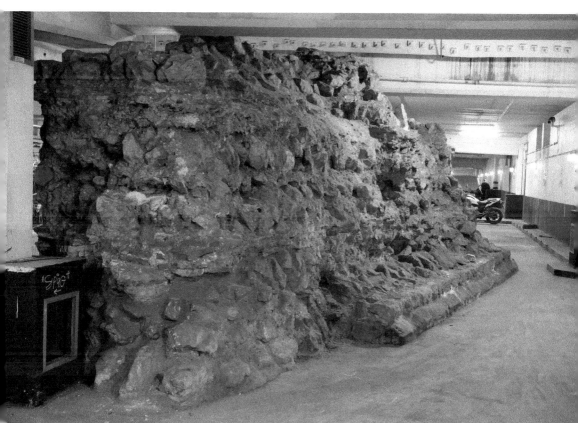

Remains of London Wall.

London Wall, near the Tower of London.

City from Southwark '[is] so called of London-Bridge, whereon it standeth. This was one of the four first and principal Gates of the City, and was long before the Conquest'.

Each chapter includes comment on the topography around the immediate area of each gate and where there is a point of interest or relevance, such as a nearby building. For example, three churches that stood near the gates are named after St Botolph, the patron saint of travellers. When Botolph died in 680, after a long life of Christian endeavour, his remains were divided into three parts: the head was taken to Ely, the body to Thorney Abbey and the remainder to Westminster Abbey. The relics were eventually brought through the City gates of Aldersgate, Bishopsgate, Aldgate and Billingsgate. The latter church was destroyed in the Great Fire (1666) and never rebuilt, while the others still remain.

The organisation of the chapters on the main gates is based on a west to east direction, from Ludgate to Aldgate. Unless stated otherwise, any specific reference to the gates will be by their known names – Ludgate, Newgate, etc. Such a short book cannot cover in detail this rich seam of history, but it is hoped that it will bring a flavour and an awareness of the significance of these gates in London's fascinating past.

Ludgate

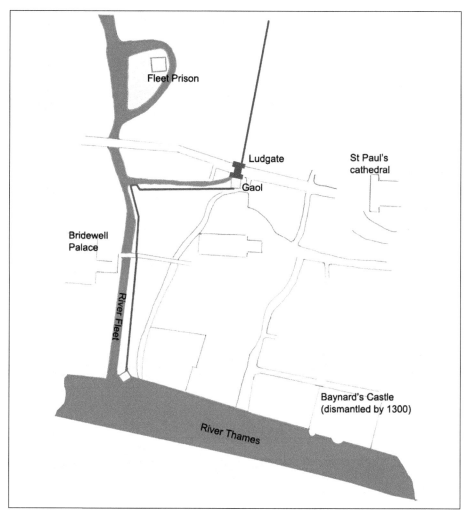

Map of Ludgate.

Ludgate was located to the south-west of the City wall. According to a medieval myth London was founded hundreds of years before the Romans arrived and King Lud built its walls. The tale is ascribed to Geoffrey of Monmouth (*c.* 1095– *c.* 1155), who also said that when Lud died his body was buried near a gateway called in Saxon times – 'Ludgate'. It took centuries to finally dismiss this myth, as well as the claim that Lud was an historical figure. The name Ludgate is generally accepted to derive from the Old English, meaning 'postern' or 'swing gate', as in *hlid-geat* from *hlid* ('lid', 'opening', 'gate') and *geat* or *gæt* ('gate', 'passage').

Excavations around Ludgate have found many Roman artefacts. Archaeologist Peter Rowsome commented in 2014 that the 'construction and maintenance of the western side of the City's defences dominated the development of the Ludgate area in the Roman and medieval periods ... A gate at Ludgate would have provided access between the south-western part of the settlement and the industrial and waterfront development of the lower Fleet valley as well as nearby burial grounds'. The late curator and archaeologist Ralph Merrifield adds that there must have been a Roman street on Ludgate Hill leading to Ludgate, a major thoroughfare that was diverted when St Paul's was founded in the early seventh century.

Any attempt to take the City had to come through the gates. After his victory at Hastings, William the Conqueror secured Kent and southern England and moved on London. Finding the entrance to the City from the south heavily defended, William and his troops took a detour and eventually established himself at Westminster Palace. After a mixture of negotiations, promises and bribes, William won over prominent Londoners and nobles. Ludgate was opened and William's troops finally entered the City. William was crowned king of England at Westminster Abbey on Christmas Day in 1066. Following the Norman invasion, defence of the City was reinforced with the construction of Baynard's Castle and Montfichet's Tower on the western side, and the Tower of London in the east.

In 1554, an attempted revolt on London came from Thomas Wyatt, although this stuttered to a halt at Ludgate. Many opposed Queen Mary's Catholicism when she came to the throne in 1553, as well her proposed marriage to Phillip of Spain. Wyatt marched with 4,000 men to London on 6 February, arriving at Ludgate on 8 February, but the gate was shut against him and its 6-foot-thick walls were too difficult to breach. Wyatt knocked heavily on the gate and demanded to be admitted. William Howard, Lord Admiral, had secured control of the gate with a force of the queen's men and refused to open it.

Wyatt rested at the nearby Bell Savage Inn and then decided to retreat. With only sixty men, he turned back to Charing Cross. At Temple Bar he was met with a powerful contingent of troops and, realising he stood no chance, he surrendered. His cause was lost, and he was tried for treason and executed on Tower Hill on 11 April.

Guarding the gates was of paramount importance. Ordinances were issued stating that a watch at the gate must be armed during curfew to question any suspicious persons trying to enter the City. The watch had to let the chain be drawn up and then ask:

... the King has given charge to us that no person shall enter his city by force of arms ... we pray that you will not take this amiss; you who are upon your palfreys, and you folks who come without bringing great horses or arms, you may enter, as being peaceful folks. And if they will not thereupon turn, then let the portcullis down by those of your people above, that so other persons may in no way enter.

(W. G. Bell, *Unknown London*)

All the City's entrances, William Chamberlayne noted in 1669, 'are kept in good repair, and all are shut up every night with great diligence'.

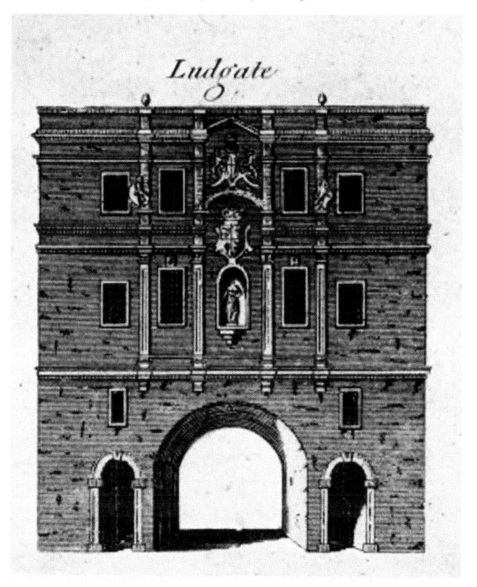

Early Ludgate. (Ditchfield, *Memorials of Old London*, 1908)

At night the streets could be dangerous and precarious places in the absence of lights. Robbery was rife and many open covers were traps in waiting for those trying to navigate their way in the dark. 'Linkboys', boys who carried a flaming torch to light the way for pedestrians at night for a small sum, congregated at Temple Bar and London Bridge. Other dangers included narrow streets, ill-drained houses, a lack of pavement, the insufficiency of water and overcrowding.

The upper rooms in Ludgate (rebuilt in 1215) were used as a City gaol from 1378 for freemen and women charged with minor offences. The gaol provided a rag to riches story with regard to Stephen Foster, who was a prisoner at Ludgate. While begging at the gate a rich widow paid the debt he owed for his release. Stephen married the widow, Agnes, and became a successful businessman and Lord Mayor of London. After his death, Agnes honoured his wishes that conditions at Ludgate be improved. Prisoners became the beneficiaries of free lodging and water as well as an open-air 'walking place'. In 1463, a tower was added to the gate to increase the capacity and a plaque fixed on the quadrant, which was dedicated to Stephen Foster:

> Devout souls that pass this way,
> For Stephen Foster, late Mayor,
> Heartily pray,
> And Dame Agnes his Spouse,
> To God consecrate,
> That of Pity, this House made
> For Londoners in Ludgate,
> So that for Lodging and Water,
> Prisoners here nought to pay,
> As their Keepers shall all answer
> At dreadful Dooms-day.

It seems that Stephen Foster's wishes were not upheld. John Strype (1643–1737) in his *A Survey of the Cities of London and Westminster* (1720) described the conditions in 1659 as oppressive, and the prisoners were expected to pay for everything but water. The master and his guards helped themselves to most of the bequests as well the alms collected by prisoners begging at the gate. In 1711, the *Spectator* commented on the begging: 'Passing under Ludgate the other day, I heard a voice bawling for charity … Coming near to the gate, the prisoner called me by my name and desired I would throw something into the box.'

The Great Fire, which ravaged so much of the City in 1666, caused damage to Ludgate and is depicted in a painting of 1670. Also shown in the image is the old St Paul's, engulfed and eventually destroyed by the fire. When St Paul's burned down on the third day of the fire a thunderstorm broke out with forks of lightning radiating from the blazing building. As the roof melted, streams of molten lead were sent pouring down Ludgate Hill 'glowing with fiery redness' as people ran for their lives.

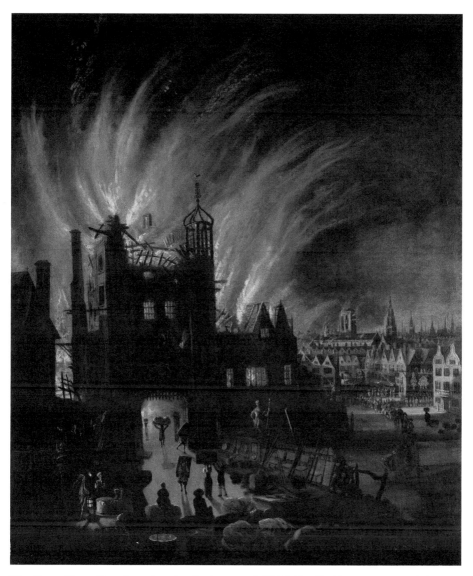

The Great Fire of London, showing Ludgate and Old St Paul's. (Anonymous artist)

Ludgate stood at a busy and important intersection. To the east of Ludgate stands St Paul's Cathedral, which sits near the top of Ludgate Hill, one of the highest points in the City. To the south-west stood Blackfriars Friary where the friars had moved from Holborn in 1276. The friary was used for many important events and occasions, such as meetings of Parliament and the divorce hearing between Henry VIII and Catherine of Aragon in 1529. Nine years later Henry VIII dissolved the friary, and the grounds and buildings were sold off.

To the west ran the River Fleet, where Fleet Bridge linked Fleet Street and Ludgate Hill. In the late seventeenth century the satirist Jonathan Swift gave a

vivid picture of the Fleet: 'Seapings from butcher's stalls, dung, guts and blood, Drowned puppies, stinking sprats, all drenched in mud, Dead cats and turnip-tops come tumbling down into the flood.' By 1766 the river was covered over between Fleet Street and the Thames; it survives today as the largest of London's subterranean rivers.

Close to the gate was the Bell Savage Inn, or La Belle Sauvage. First documented in 1452, plays were performed in its courtyard prior to the establishment of public theatres in London. The Bell Savage was one of London's finest coaching inns, boasting at one time forty rooms and stabling for 100 horses.

As London expanded, particularly to the west of the City, the amount of traffic passing through the gates became greater. Such was the increase in vehicles that a proclamation in 1635 attempted to limit them. Ludgate Hill was such a busy stretch of road that Samuel Pepys noted an early form of road rage when he commented in 1668 that the 'coachman on Ludgate Hill lighted and beat a fellow with a sword'. Writing in the nineteenth century, Walter Thornbury stated that 'Ludgate Hill and Street is probably the greatest thoroughfare in London' and this is vividly reflected in Gustave Dore's illustration *Ludgate Hill – A Block in the Street* (1872).

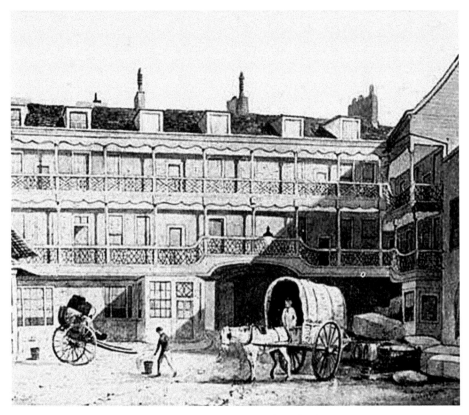

The Bell Savage Inn. (C. G. Harper, *The Old Inns of England*, 1906)

The gateway stood near the church of St Martin within Ludgate, named after St Martin of Tours – patron saint of beggars. Churches dedicated to him are often located just within the gates of a city. St Martin within Ludgate, of which the earliest written reference is from 1174, was rebuilt in 1437, repaired in 1623, but destroyed by the Great Fire in 1666. Rebuilding the church was completed in 1703 and a plaque on the outside wall of the church denotes the site of Ludgate gateway.

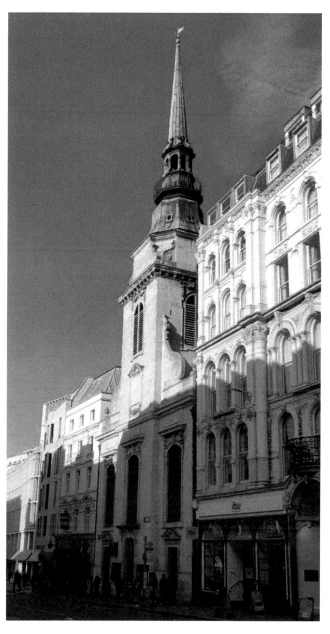

St Martin's Church,
Ludgate Hill.

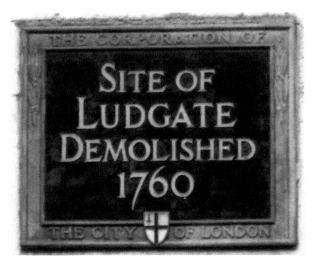

Plaque denoting the
location of Ludgate,
St Martin within Ludgate.

Ludgate and the prison were demolished in 1760 and a clear road was open all the way to St Paul's. Bricks from the gate were sold as building materials for £148 and the statue of Queen Elizabeth, which stood on the west side of the gateway, was relocated to the outer wall of St Dunstan-in-the-west Church, where it remains and is thought to be the oldest outdoor statue in London. The statue was restored and unveiled in 1928 by Millicent Fawcett, a leading suffragist. The figures of Lud and his two sons, Androgeus and Theomantius, found a home in the porch of St Dunstan's.

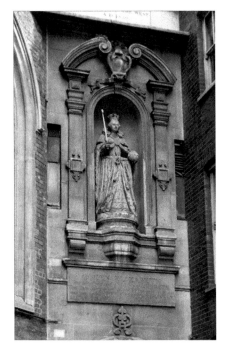

Statue of Elizabeth I, St Duntsan-in-the-West,
Fleet Street.

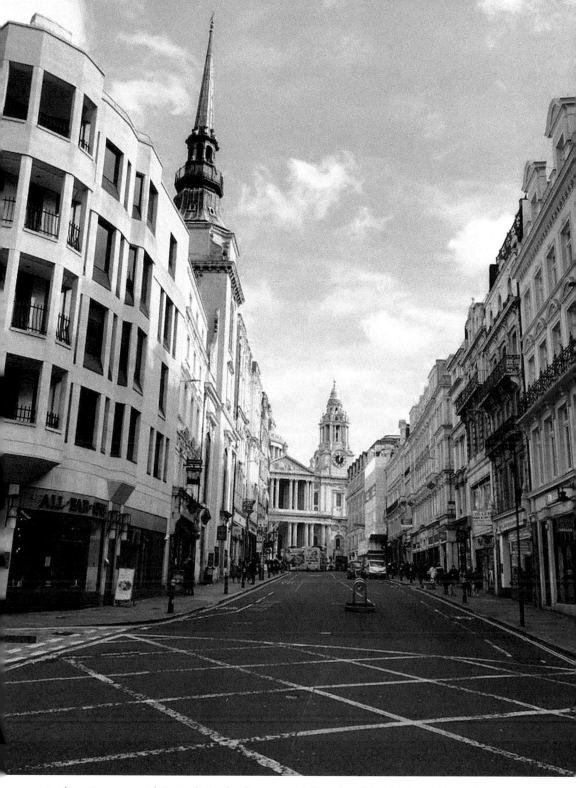

Ludgate in 2020, with St Paul's in the distance and the spire of St Martin within Ludgate to the left.

Newgate

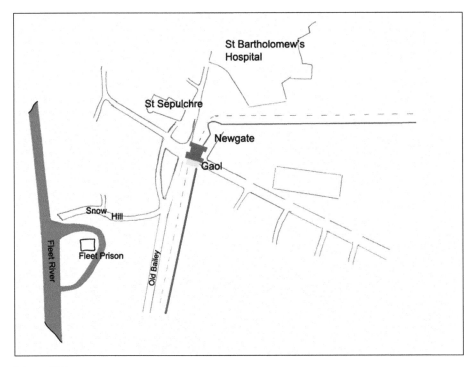

Map of Newgate.

Newgate was one of the original gates in the City wall and, along with Ludgate, one of the two routes west from the Roman city. It was first referred to by the Saxons as Uuestgetum in 857 ('the West Gates') – the plural suggesting a double gateway. It acquired its later name – the New Gate – after it was rebuilt in the early Norman period. The gate was a double-archway entrance into the city, containing a portcullis to seal off access when needed.

According to Ralph Merrifield, Newgate is the only Roman gatehouse of the City that we know much about: 'It is likely that a gate existed as a freestanding

structure [a triumphal arch]' prior to the construction of the wall. Based on observations made between 1875 and 1909, the Roman ground plan was like an 'enlarged copy of the west gate of the fort, with a double entrance flanked by rectangular guard-rooms which projected respectively 7 and 14ft in front of the Wall and similar distances behind'. Between 1966 and 1969, part of the internal face of the City wall was discovered in the basement of the Central Criminal Court. Coins were also found, dating the construction from around AD 200. Near to where the gate stood are some well-preserved remains of a section of Roman wall and a medieval bastion in a basement beneath Merrill Lynch, near Giltspur Street.

Excavations in the early twentieth century showed that the gateway at Newgate in the Roman period was almost identical to the one at Ludgate. The Roman route from Newgate led from the main east–west road of the City, giving access to two important Roman highways: Watling Street to the north-west, and the road to Silchester and the west.

Writing in the late nineteenth century, H.B. Wheatley stated that 'it was long supposed that Ludgate was the chief entrance to the city from the west, but, in spite of its name, there can be little doubt that for some centuries the great western approach was made through Newgate'. However, Peter Ackroyd suggests that up to the Conquest, at least, Ludgate was the principal entrance to the City.

The medieval gate was erected during the reign of Henry I (1100–35) and, with the burning down of St Paul's in 1086, the rebuilding encompassed many streets and lanes as well as the gates. St Paul's was so much larger than the previous building that it blocked traffic running from east to west of the City. Stow wrote that 'a new gate was made, and so called, by which men and cattle with all manner of carriages, might pass from Aldegate, through West Cheape by [St] Paules on the North side through Saint Nicholas Shambles and Newgate market to Newgate, and from thence to any part Westward over Holborn bridge'.

The gatehouse was known as Newgate by at least 1188, although it was also referred to as 'Chamberlain Gate' until 1285, presumably after William the Chamberlain, who owned a vineyard at Holborn. Newgate became inextricably linked with the notorious prison, as the medieval gateway was used for housing some of the most violent criminals. Other buildings were added and the prison was extended and rebuilt many times, and remained in use from 1188 to 1902.

In 1308, special orders were issued concerning the guarding of the gates. The wards adjoining each gate had to supply a certain number of men-at-arms. Newgate was supplied with twenty-six men. Two years later a royal writ was issued for the punishment of anyone who damaged the City walls, gates and posterns.

A number of important historic sites were in close proximity to Newgate: the Franciscan Friary of Greyfriars; the Church of the Holy Sepulchre to the west; northwards was St Bartholomew's hospital, founded in 1123. An adjoining sessions court was also added to the gatehouse. In the street outside the gates,

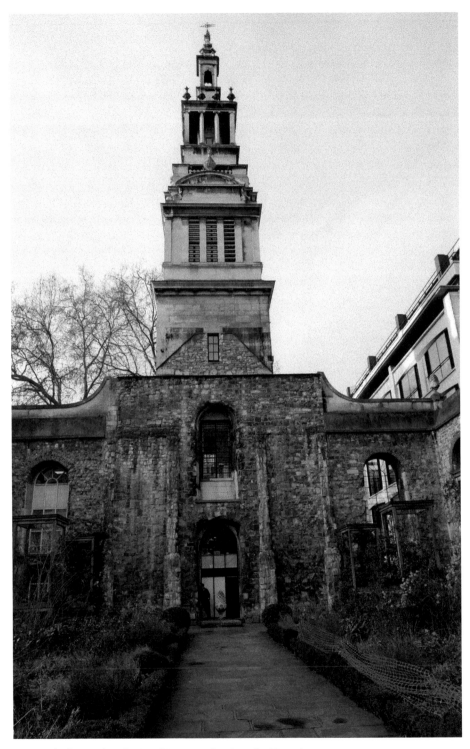

Ruins of Christ Church Greyfriars, on the site of a Franciscan monastery.

running south parallel to the defensive ditch, was Old Bailey. This had existed from 1166 and gave its name to the Central Criminal Court. To the east was Stinking Lane (now King Edward Street), once known for its slaughterhouses.

The main street from the gates into the City came to be known as Newgate Street. Parts of the street were previously called Blowbladder Street and the Shambles, names derived from the butchers' stalls on the eastern part of the street by 1196. A general market was located on Newgate Street prior to the Great Fire and offal was brought through the lanes of the City by which 'grievous corruption and filth have been generated' (Wheatley).

The nearby Saracen's Head was a celebrated tavern and coaching inn that stood on the north side of Snow Hill, adjacent to the church of St Sepulchre-without-Newgate. The inn dated back to the sixteenth century and was demolished in 1868 when improvements in the area were being made, including the construction of Holborn Viaduct. In November 1661, Pepys recorded that he went 'to the Saracen's Head to a barrel of oysters'.

Newgate Prison became the first penal institution to implement the legal reforms of Henry II (1133–89), which required places to be built where the accused would stay while royal judges debated their innocence or guilt and subsequent punishment. The prison also gained a notorious reputation for its conditions, appalling squalor, almost non-existent ventilation and the appalling stench that emanated from it. Outbreaks of 'gaol fever', a particularly virulent form of typhoid, occurred regularly and killed many of its inmates.

In an effort to enlarge the prison, one of the Newgate turrets, which still functioned as a main gate into the City, was extended in 1236. Further additions included new dungeons and adjacent buildings. However, Newgate was in further need of repair by the fifteenth century; as such, a separate tower and chamber for female prisoners was added in 1406. Eight years later, the prison was in such a loathsome condition that the keeper and sixty-four of the prisoners died of the prison plague. Such was the state of decay that many prisoners continued to die from overcrowding, disease and poor sanitary conditions. As a result of this the gate was rebuilt between 1423 and 1432 with funds bequeathed by Richard (Dick) Whittington. Over the course of excavations made in 1874–75 for the improvement of the western end of Newgate Street, the huge foundations of Whittington's gate were discovered several feet below the present roadway. The prison occupied all the upper stories of the gatehouse and behind the gate the prison building extended some way back, parallel with Newgate Street.

A constant theme in the history of Newgate Prison was the fear and loathing it generated, and this was reflected in the regular attacks on it. The first major assault came in 1381 when Wat Tyler's peasant followers inflicted considerable damage on the prison. Anti-immigrant riots shook London in the spring of 1517 when crowds in their hundreds attacked the homes and shops of immigrants. Crowds descended on Newgate Prison, where several men who had been arrested

for assaulting foreigners were freed. The mob then marched east, near to Aldgate. At least fifteen of the rioters were executed for treason.

In the tumultuous decade of the 1640s condemned prisoners at Newgate had received arms smuggled in for them to resist their fate. On 26 December 1648:

> ... many of the prisoners' wives ... brought swords and rapiers under their coats and ... delivered the said Weapons to the 15 condemned prisoners, who taking their opportunity, about 7 of the clock at night, ran violently at the Turnkey and the rest of the Keepers, wounding them, and forced their passage down the stairs, all of them making a clear escape away.
>
> (Gordon, 1902)

The gate, as with many surrounding buildings, was damaged in the Great Fire. Newgate was rebuilt with some splendour in 1672, with a postern for foot passengers. On the east side of the gate were three stone statues of Justice, Mercy and Truth. On the west side stood Liberty, Peace, Plenty and Concord. There was a carriage archway in the centre, which divided Newgate Street from Giltspur Street. London historian Sir Laurence Gomme, writing in *The Gentleman's Magazine* in 1904, noted that the footpath 'supplied a shelter for two or three old women, who fried small sausages for sale; and in the centre was an entry into the then chief prison; the mendicant prisoners for debt stood within the iron-grated door ... the upper chambers of the building constituted the prison for felons where a door was opened on the south side adjoining the old wall which still abuts upon the street by the ordinary's house, and it was from this door that the malefactor's were received into the cart for their last journey to Tyburn'.

St Sepulchre-without-Newgate stood opposite the Newgate entrance. The church today contains, in a glass cabinet, the bell that was rung on the evening prior to an execution. On the final evening the last sacrament would be offered and at midnight a bell was tolled outside Newgate. This ritual started in 1604 and involved the handbell being rung loudly accompanied by the following cry:

> All you that in the condemned hole do lie,
> Prepare you, for tomorrow you shall die;
> Watch all and pray; the hour is drawing near,
> That you before the Almighty must appear.
> Examine well yourselves; in time repent,
> That you may not to eternal Flames be sent.
> And when St Sepulchre's Bell in the morning tolls,
> The Lord above have mercy on your souls.

On execution days the condemned would hear the bells of nearby St Sepulchre before being placed on the back of a horse-drawn cart to commence their last journey. Large crowds assembled and lined the route from Newgate to Tyburn,

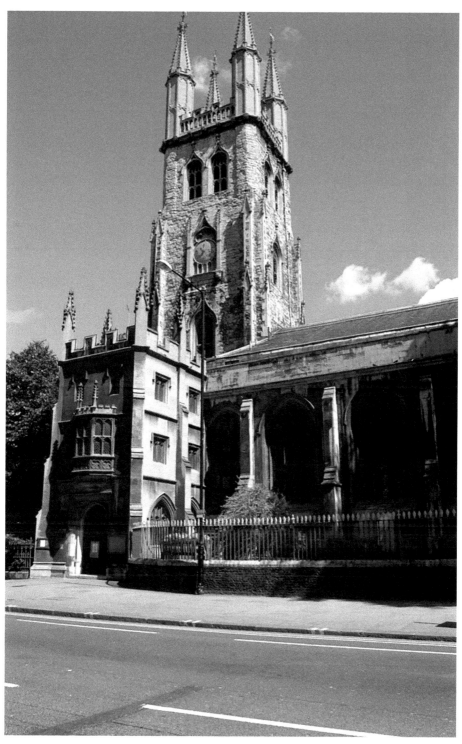

St Sepulchre's Church, opposite Newgate.

hanging from windows cheering or jeering and throwing all kinds of filth at the condemned. This huge throng of people could be both dangerous and intimidating, and many accidents and fatalities resulted. In June 1698, as the cart left Newgate for Tyburn it stopped at St Sepulchre-without-Newgate, where a large crowd had congregated. As a result, the wall at the corner of the churchyard collapsed, killing one man and injuring up to forty others – four of whom died later. Such was the confusion that the cart had to take a detour from the usual route.

By the eighteenth century, ventilators were introduced into Newgate to deal with the foul air. However, they became neglected, and the infectious disorder of the gaol returned. In 1750, sixty-four people at the Old Bailey, including two judges, the Lord Mayor, several counsellors and prisoners, died from the toxic air. In April 1752, windmill-operated ventilators, invented by Revd Dr Stephen Hales, were fixed on top of Newgate Prison. The famous gate was demolished in 1777. It was the last of the gates to disappear, although the prison went through further rebuilding, particularly the new prison in 1782, before it was finally closed in 1902, then demolished in 1904.

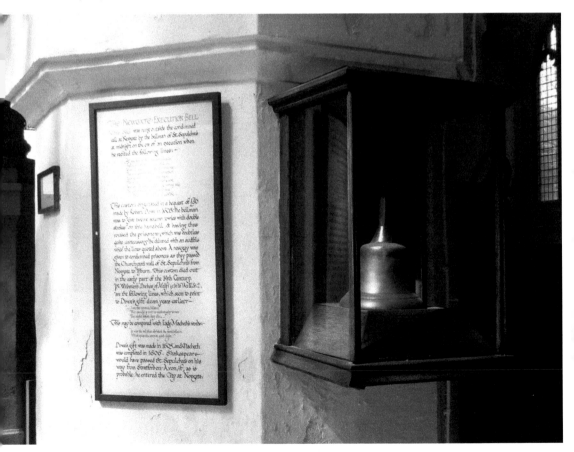

'The Newgate Execution Bell' in St Sepulchre-without-Newgate.

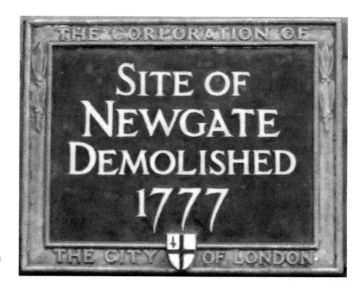

Right: Plaque denoting the site of Newgate.

Below: Newgate, 2020. The Central Criminal Court is on the right.

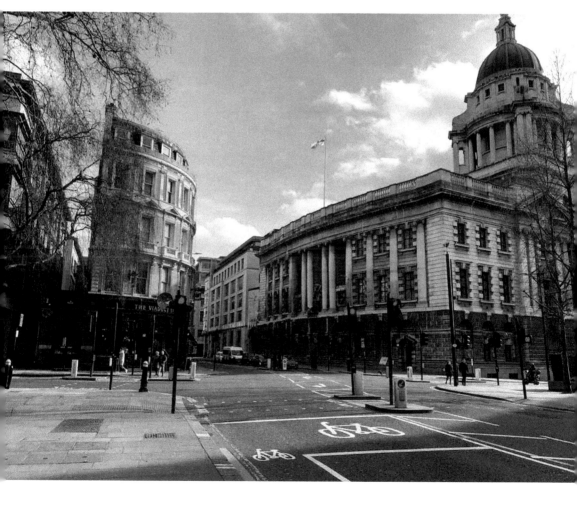

Aldersgate

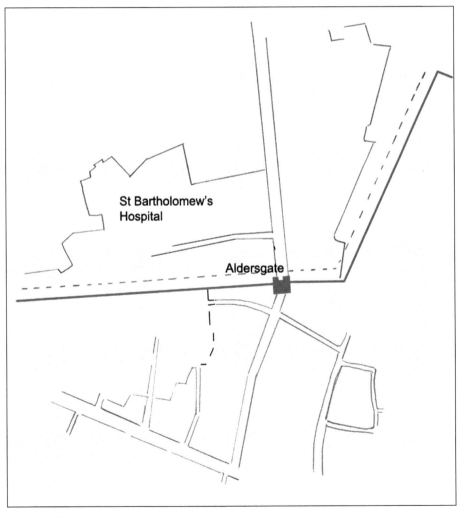

Map of Aldersgate.

The gateway of Aldersgate was situated to the north-west of the London Wall. A plaque outside the Lord Raglan pub on St Martin's Le Grand marks its location. There is little or no mention of Aldersgate by name prior to the Conquest. The general belief is that from the eleventh and twelfth centuries it was known as Ealdredesgate, associated with a man called Ealdred and from the Old English *geat*. It was referred to in later times as Aldresgatestrete, Aldredesgate and Aldrishgate.

Although disputed, Aldersgate is believed to be the only Roman gateway that was added to the City wall after the wall's construction. However, Richard Hingley (*Londinium*) suggests that the gateway has 'been interpreted as a later

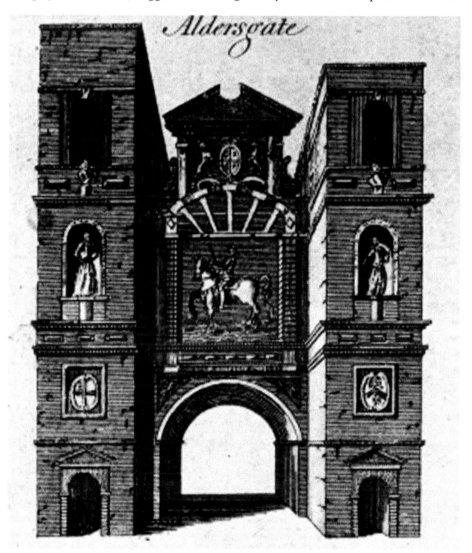

Seventeenth-century Aldersgate. (Ditchfield, *Memorials of Old London*, 1908)

feature of the Wall, although evidence for a road pre-dating the construction of the Wall at this point may suggest that it was an original gateway in this circuit'.

Ralph Merrifield states that the gate was 'initially the west gate of the fort [and] probably provided all the access needed in this part of the wall … Like the north gate of the fort (Cripplegate), the west gate would have given access only to minor roads, probably mainly used by the military occupants'. The Roman fort never housed a permanent regiment. It accommodated around 1,000 men and was the home of the ceremonial guard that served the governor of Britain. It would have contained the soldier's barracks and support buildings. Two main thoroughfares dissected the fort: one ran west–east and the other ran south–north. This is where the west–east thoroughfare would have entered the fort. Evidence of a Roman cemetery outside the wall has been uncovered in past excavations. Remains of the old western fort gate exist in a private area of the car park near the Museum of London.

After the Romans left Britain the defensive system of the City managed to hold off later Danish attacks – in 994, 1009 and 1013 – which suggests that the defences were probably in good order. During the medieval period the Wall and ditch were continually repaired and maintained, and it appears from archaeological evidence that bastions were added to the western circuit at this time.

Bastion, near St Giles Church.

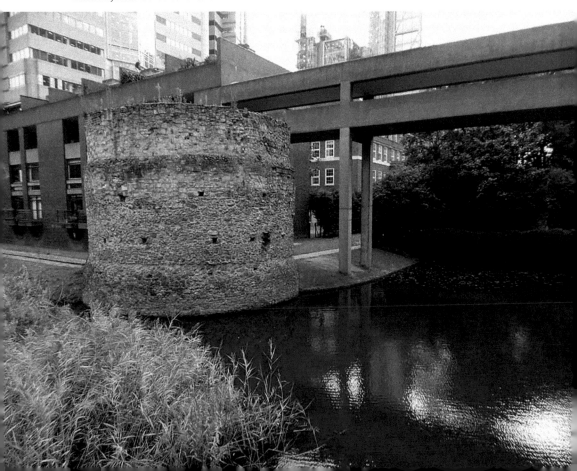

Close to the gate was St Anne and St Agnes Church, and to the west was Greyfriars Friary, which existed from 1225 to 1538. Aldersgate Street ran north from the gate, while St Martin's Le Grand ran south. To the east of St Martin's Le Grand stood the Collegiate church and monastic precinct of St Martin's, which was dissolved and demolished during the reign of Henry VIII. The church was responsible for the sounding of the curfew bell in the evenings, which announced the closing of the City's gates. Immediately to the north of the wall was St Botolph's Church, first recorded between 1108 and 1122. The churchyard was added in 1348 and extended in the fifteenth century.

Neighbouring the gate on the east side was the Castle Inn, described by John Strype as 'very large, and of a considerable resort. In the Yard are several good Houses for private Families'. Just to the south of the gate was the Bull and Mouth coaching inn, originally called the Boulogne Mouth in reference to the town being besieged by Henry VIII in 1544–56. The inn was destroyed in the Great Fire but rebuilt. Almost next door to the Bull and Mouth was a Quaker meeting house, which was established in 1675.

In 1335, it was ordered that a small house over the gate was to be used by the gatekeeper. Later, John Blytone, the first known 'sword bearer' of the City of London, was granted the 'Gate of Aldichgate' – the mansion over Aldersgate – for life when he resigned in 1395. The common crier was another official who occupied the apartments. Stow tells us that the gate had increased

St Botolph's Church, Aldersgate, from Postman's Park.

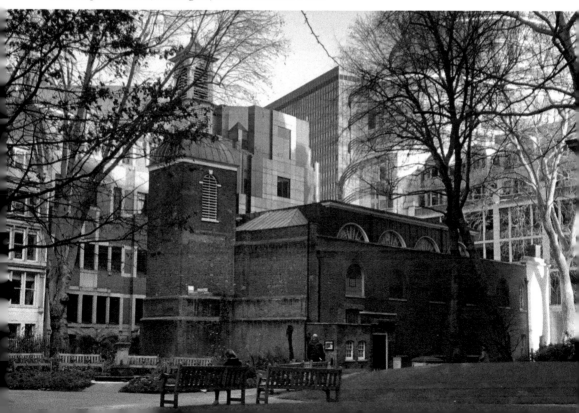

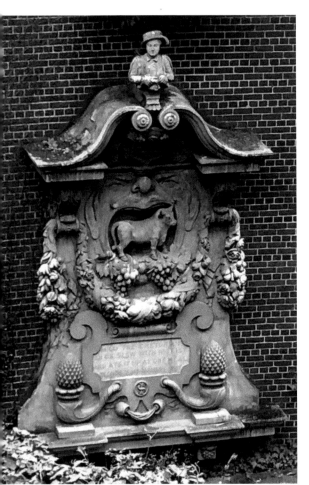

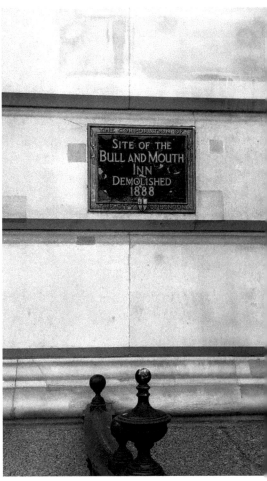

Above left: Sign for the Bull and Mouth in the Museum of London rotunda.

Above right: Plaque showing location of the Bull and Mouth, St Martin's Le Grand.

with buildings on the southside: 'A great frame of timber hath been added ... containing divers large rooms and lodgings.' The east side saw the addition of a timber building with a large floor, paved with stone or tile and a well 'of a great depth'. During the 1540s the printer John Day lived over the gate. This is where he printed the Folio Bible, dedicated to Edward VI, in 1549. He also printed other publications, including one of the earliest almanacs, *A Prognostication for the Year of Our Lord,* in 1559 and in 1563 what became known as *Foxe's Book of Martyrs.*

Riots often posed a threat, and the gates came into their own at such times. In 1326, apprentices of the Bench – those in legal training – rioted in Aldersgate with swords drawn. As the bells rang to signal a riot, a crowd assembled and a citizen amused himself by shooting an arrow, which killed an innocent bystander.

In the early sixteenth century, the condition of the gate was described as 'stinking so sore' and in jeopardy 'of falling down'. It appears that the same gate was still there when James I entered London in 1603. However, in 1616 the entire gate was rebuilt from a design by Gerard Christmas and helped by a bequest from Mr William Parker, a merchant. Part of the medieval gateway was uncovered in the 1920s, showing that it had square, projecting towers and pedestrian footways either side of the carriageway. As with the other gates to the west – Ludgate and Newgate – Aldersgate was damaged by the Great Fire, although all the gates were repaired afterwards.

By the 1650s, Aldersgate Street was lined with impressive houses and was described by James Howell in 1657 as 'handsome, with the look of an Italian street more than any other in London, by reason of spaciousness and uniformity of buildings, and straightness thereof, with the convenient distance of the houses'.

The gates policed the movement of traffic and people, particularly suspicious or threatening persons. William Maitland's *Survey of London* (1756) provides some idea of how the ward was kept safe at night: 'There are to watch at Aldersgate, and other stands in this Ward, every Night, one Constable, the Beadle, and 44 Watchman. And in the liberty of St Martins-le-Grand, which is in this Ward, 12. In all 56.'

As James I had entered London via Aldersgate it was fitting that the new gate in 1617 would have a dedication to him. Walter Thornbury wrote that over the arch of the gate was a 'figure in high relief of James I., but the building itself was heavy and inelegant. The imperial arms surmounted the figure, for through this gate the Stuart first entered London in 1603 when he came to take possession of the Crown'. Stow describes the gate as having on the north side, in a large square over the arch, a figure of James I on horseback 'in the posture as he came into England'. On the eastern side was an effigy of the prophet Jeremiah with lines from his prophecies: 'Then shall enter into the gates of this city kings and princes...and this city shall remain for ever.' On the south side were the effigies of James I sitting in his 'Chair of State in his Royal Robes'. A stained-glass window in St Botolph-without-Aldersgate depicts James I entering the City of London by Aldersgate. The adornment of the gates with effigies, coats of arms, inscriptions, statues, mythical, royal and biblical depictions remind us of the civic importance of the gates in the fabric of the City.

Pepys witnessed something altogether more gruesome in 1660. As he walked towards St Bartholomew's, he 'saw the limbs of some of our new traytors set upon Aldersgate, which was a sad sight to see; and a bloody week this and the last have been, there being ten hanged and quartered'. That year saw the Restoration of Monarchy after two decades of Civil War, the execution of Charles I, the abolition of monarchy and the House of Lords followed by republican governments. Reprisals on those who had signed the death warrant of Charles (the regicides) followed and some were captured, stood trial and executed. The punishment for treason was to be hanged, drawn and quartered, and there would be a display of

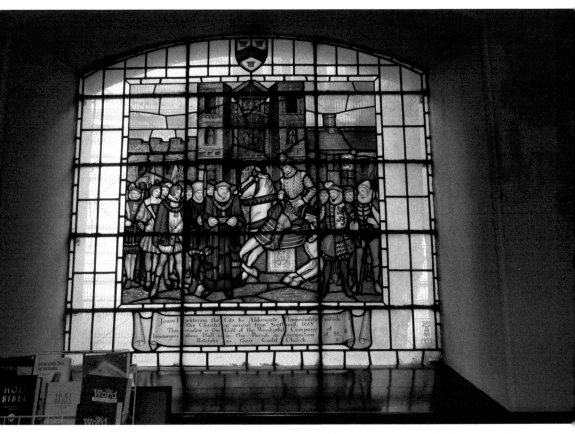

Stained-glass window in St Botolph's, Aldersgate, showing James I with the gate in the background.

the body parts on various gates around the City. The fate of one of the regicides, Thomas Harrison, is summed up by the following comment:

> ... his Head severed from his Body, and his Body divided into Quarters, which were returned back to Newgate upon the same Hurdle that carried it. His Head is since set on a Pole on the top of the South-East end of Westminster-Hall, looking towards London. The Quarters of his Body are in like manner exposed upon some of the City Gates.

In the uncertainty of the transition to Restoration, on 9 February 1660 the Council of State ordered that steps be taken to coerce obedience from the citizens of London. General George Monck ordered that the gates of the City of London, portcullis, posts and chains be 'forthwith destroyed'. Soldiers were duly dispatched to the various gates, but they found the task difficult. At Aldersgate, as well as Newgate, the gates proved too strong, hence little damage was done, while at Bishopsgate, Cripplegate and Aldgate the gates were 'cut to pieces'. The decision

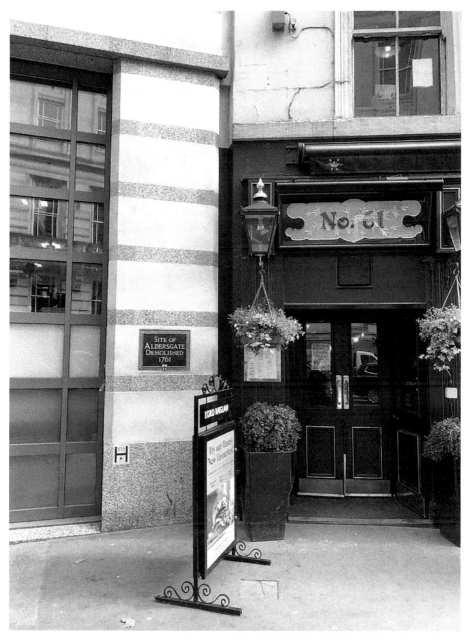

Plaque showing the site of Aldersgate outside the Lord Raglan, St Martin's Le Grand.

was not a popular one, and Monck apologised two days later for the destruction of the gates. It was followed by another instruction to the aldermen of the City on 21 February to restore them all 'as they shall see cause'. The gates survived for at least another century. In the case of Aldersgate, it was demolished in 1761 and sold for £91.

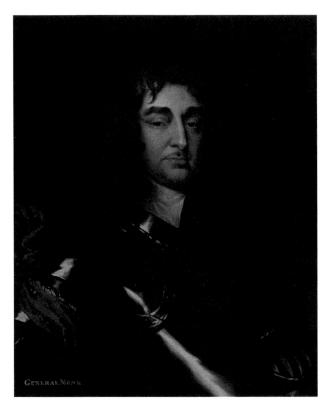

GENERAL MONK

Left: *Portrait of General Monck*, attributed to Jacob Huysmans, 1665.

Below: Aldersgate, 2020. Lord Raglan is to the right, which marks the site of the gate.

Cripplegate

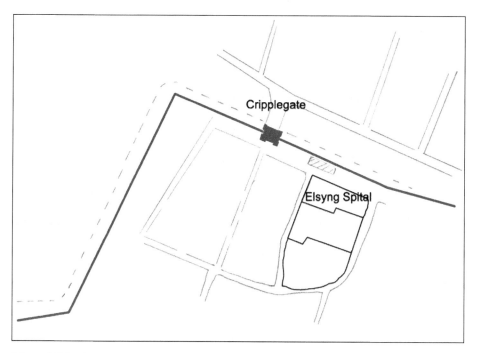

Map of Cripplegate.

Cripplegate was one of the original Roman gates leading into the Roman fort at the north-west corner of the City. Ralph Merrifield describes the fort as having 4-foot-thick walls, provided with 'normal defensive attributes of external ditch, internal bank and turrets placed internally at the rounded corners ... The north gate became the Roman and medieval gate Cripplegate'.

In the eleventh century the area was called Cripelesgate, Cripelesgata or Crepelesgate. Other variations that came later were Crepulgate in 1423 and Creplegate by 1560. *The Oxford Dictionary of London Place Names* identifies this from the Old English *crypel-geat*, meaning 'a low gate in a wall for creeping

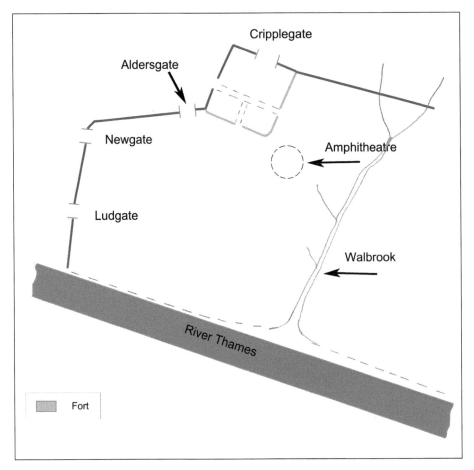

Cripplegate and site of the Roman fort.

through'. It also adds that the nearby church of St Giles-without-Cripplegate, founded in the eleventh century, is dedicated to the patron saint of 'cripples'. However, the first church was built slightly earlier so this would bear out the point that the dedication to St Giles may have been a later, probably mistaken, etymology. Revd William Denton, a nineteenth-century historian of Cripplegate, explains that the name originated from the Anglo-Saxon cruplegate, meaning 'a covered way' or 'tunnel'. An earlier explanation is offered by Stow, who noted that in 1010 the Danes brought the body of King Edmond the Martyr from Bury St Edmunds to London via 'Cripplegate, a place called of Criples begging there: at which gate (it was said) the body entering, miracles were wrought, as some of the Lame to go upright, praysing God'.

Twelfth-century cleric and administrator William FitzStephen described the type of activity around Cripplegate: 'when that great marsh which washed the walls of the City on the north side is frozen over, the young men go out in crowds to divert themselves on the ice'. This moorland stretched across the northern section of the

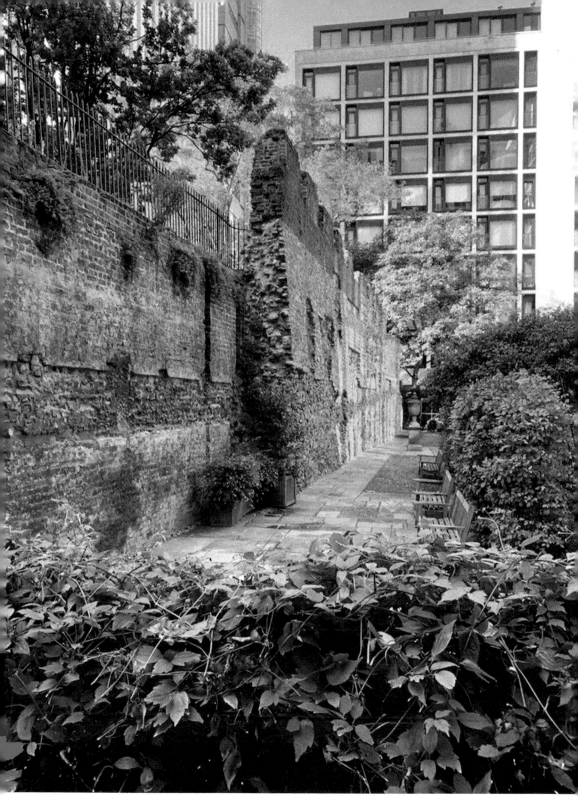

Remains of London Wall, near Cripplegate.

ROMAN CITY WALL
ACT OF PARLIAMENT
LAID OUT AS A GARDEN
GEORGE KEMP M.A. Rector
WILLIAM SMITH
CHURCHWARDENS

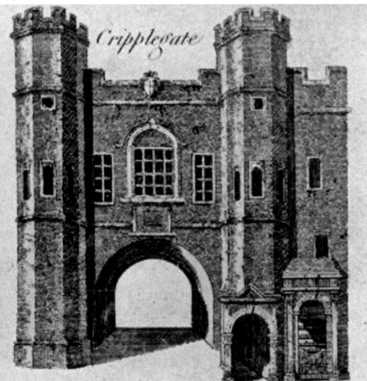

Cripplegate

Above: Plaque close to Cripplegate. Nearby St Alphage was built directly upon London Wall.

Left: Seventeenth-century Cripplegate. (Ditchfield, *Memorials of Old London*, 1908)

wall through where two or three shallow streams wound their way. The main one, which passed under the wall, gained its name as 'the Wall Brook'.

The significance of great quantities of water coming from the north was reflected in 1244 when Cripplegate was rebuilt at the expense of the brewers. They had found it convenient to settle in the vicinity of the gate, near the moor, as it was necessary for them to have easy access for their products, and it was to their advantage to repair the gate.

Cripplegate faced the north end of Wood Street where parts of the wall can still be seen. A blue plaque at the junction of Wood Street and St Alphage Garden to the north of the London Wall marks the location of the gate.

Close to the gate, and adjoining the London Wall, was the eleventh-century church of St Alphage. A second church began as the priory church of the nunnery of St Mary-within-Cripplegate. However, the community fell into decay by 1329 and the land passed into the hands of William Elsyng, a London merchant who founded the hospital in 1330 to provide shelter and care for London's homeless blind people. It was later taken over by Augustinian canons and closed in 1536, with the Dissolution of the Monasteries. Remains of the tower of St Elysng Spital can be seen on the north side of London Wall.

St Giles-without-Cripplegate Church is uniquely surrounded by parts of the London Wall, a bastion, a lake, the Museum of London and a residential housing complex. St Giles is one of the few remaining medieval churches in the City of London despite suffering a number of fires in 1545, 1897 and devastating

Bastion, near Cripplegate.

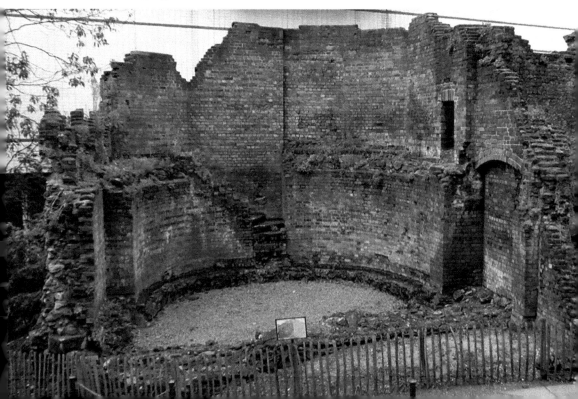

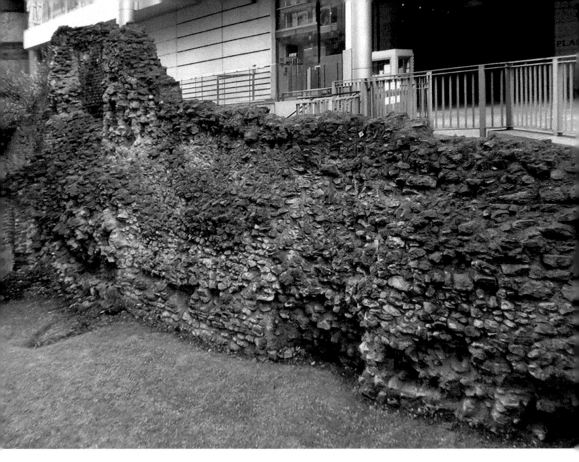

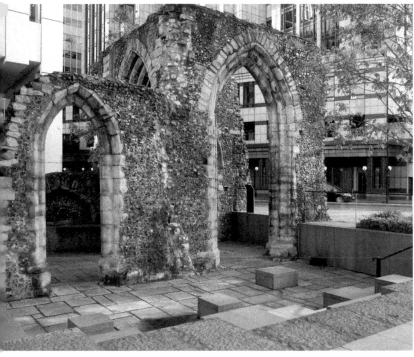

Above: Part of
the city wall and
Roman fort, Noble
Street.

Left: St Elsyng
Spital.

bombing during the Second World War. A Norman church of 1090 stood on this site and the church has many famous associations, including Oliver Cromwell, John Milton, John Foxe and Sir Martin Frobisher.

Cripplegate was variously restored and rebuilt. An inscription on the south side of the gate read: 'This gate was repaired, beautified, and the foot postern new made at the charge of the City' (Edward Hatton, 1708). It was said that Cripplegate had the appearance of a 'fortification [more] than any other gate ... It was flanked by two embattled octagonal towers, one of these being pierced for the use of foot passengers'. The gate was a plain, solid edifice and lacking any ornamentation.

The gate was closed at night, chained until sunrise and between those times mustered by a watch. An ordinance of 1312 specified that twenty armed men would guard the gate from three adjoining wards. As long as the curfew bell was ringing, the wickets (a small door or entrance) of the gate were to stand open, and when the curfew had been rung out they were to be closed. As the century progressed less care seems to have been given to the guarding of the gates. A number of entries, such as one in 1375, made it clear to the porters of the City

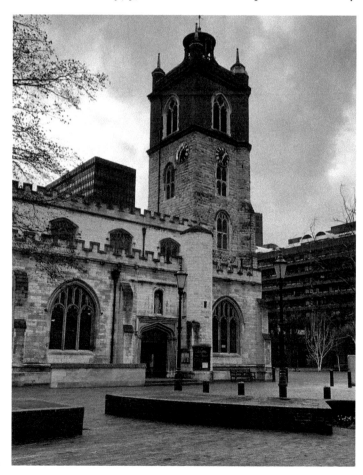

St Giles-without-Cripplegate. The medieval tower marked the north-west corner of the Roman and medieval defences. Two-thirds of the original height of the tower survives.

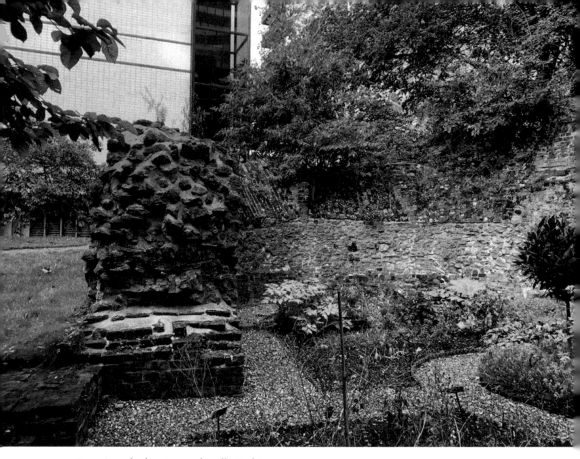

Remains of a bastion and wall, Barbican.

gates that they would suffer the pain of the pillory should they allow a leper to be brought into the City.

The City may seem an unusual choice to seek solitude, but there were hermits living variously at Aldgate, Bishopsgate and Cripplegate. At the latter, in a cell between the gate and the bastion, lived a hermit called Brother Warin (died in 1205), who was chaplain to Richard I. In 1291, a new incumbent was appointed who acted as a carer. William de Wyntreburn was admitted 'to the custody of Cripelgate, provided that he behave himself well and ... that he devote himself to his sacred office [chaplain], minister to brother Robert, the hermit ... who is feeble, and maintain him in a fitting manner for as long as he lives'. Robert died three months later after living there for some twenty years. The cell of St James later became a chantry chapel.

In the absence of a prison in the northern part of the City, any of the gates could be utilised when necessary. In 1262, some men who had broken into the Jewish quarter of the City were subsequently imprisoned in Newgate and Cripplegate. In 1311, when the pope decreed to disband the order of the Knights Templar, many were rounded up and arrested, with six Templars imprisoned in Cripplegate.

When the gates no longer functioned as a prison they became apartments over the gates and were let out to City officers. There are many accounts of how the

rooms were put to such use. In 1307, the gate was granted to Thomas de Kent, sergeant to the mayor, to 'watch and dwell there as long as he behave himself and keep the said Gate roofed at his own expense from wind and rain'. In 1316, it was granted to William de Waltham to reside there for life 'as long he keeps the house built over the gate and does not rent it to anyone else'. John Wallygtone, sergeant and common crier of the City, was given the chambers and 'other edifices over the same gate' and a stable for receiving and keeping all prisoners. Hugh Battesford was granted the use of the 'mansion over the gate of Crippelegate' in 1390 on similar conditions to previous occupants.

However, it seems that abuse and neglect of the rooms were becoming common. In 1386, an ordinance complained of the 'hurt and mischief' that had 'come to the City by grants made to various persons as well as gates, mansions and gardens'. The authorities deemed that in future no grant would be made to any of the 'gates or mansions over them and that such places will remain in the hands of the said City'. Clearly the authorities had had enough of the neglect caused by individuals leasing the rooms.

These disputes continued over time. In 1504, the City authorities stated that the rooms were in the gift of the mayor and aldermen and were once again laying down conditions. The common crier was renting a room in 1510. In 1534, one of the mayor's officers was granted the mansion over Cripplegate 'as long as he shall well and truly behave himself'. The same proviso came for all tenants. During the seventeenth century the mayor's officers continued to enjoy the apartments over the gates. In 1628, William Raven, eldest sergeant of the Chamber, resided there for fifteen years.

It appears that some of the officials were sub-renting the rooms. For example, in 1753, Stephen Montague, a clerk in the Custom House, was paying the sum of 12 guineas a year to the water bailiff. In 1750, the rooms in Cripplegate were filled with timber 'or let to anyone who would occupy them'. In the later years of the gates Mr Hayward, the water bailiff, rented the rooms for £10 per year to the widow Ann Whalley, who sold fruit and greens at a nearby yard.

The ominous named 'cages', maintained by the parish, existed for the 'deserving' and 'non-deserving poor' (the latter would likely be whipped or branded) as well as the destitute, homeless, starving and pregnant mothers. Cages also acted as a makeshift lying-in hospital, although many people ended up dying. There were a number of cages in each parish providing refuge, including one in the gate at Cripplegate. The register books of St Giles bear out some sad cases relating to the cage: in 1581, Wyllym, son of Leonarde Rule, was baptised in it; in 1595 a woman was buried who had died in the cage; 'Jane' was recorded as being born in the cage in 1586; Robert Ely, a weaver, died in the cage in 1630 (Denton, p. 87).

Concern was expressed at the degree of deterioration in the gate by 1383. A meeting of the Common Council held in the Chamber of the Guildhall stated: 'The houses and walls over the gate at Cripplegate are so ruinous and weak they will not be able to continue long without repair it is agreed that as soon as money

comes from the Chamber beyond what is reasonable ... that money shall be expended on the repair of those houses.' Some years earlier the Chamberlain's accounts for 1339 show that £10 17s 4d was spent upon the 'new wall near Cripplegate' and for the gate, kitchen and pavement £14 7s 7d was spent. A new gate was eventually built in 1491 with the financial help of Edmund Shaw, mayor of the City, who bequeathed in his will over £300 towards the building of the gate.

A list of the tolls on traffic entering the City in 1356 shows that 1d was charged on every cart with victuals or with wares for sale, 1 farthing for every horse carrying goods laden, and threepence per week for carts that brought wheat and flour. As evidence of the heavy use of large vehicles coming through the gates David Whipp states that in '1305 between 220 and 240 carts loaded with corn entered into the city through Newgate in a single day'.

We assume there were no tolls imposed when Elizabeth journeyed from Hatfield to the City via Cripplegate. After the death of her half-sister, Queen Mary, on 17 November 1558, Elizabeth succeeded her to the throne. *Holinshed's Chronicles* records that on 28 November the 'Lord Mayor, Aldermen and Common Councilmen met her at the gate of the Charterhouse ... the Mayor riding with Garter King-at-Arms and carrying a sceptre before her, she entered Cripplegate, and so passed by the walls to Bishopsgate and from thence to the Tower'. Other royals had, in previous times, also entered the City via Cripplegate. During the Wars of the Roses Henry VI and Queen Margaret arrived here after their victory at St Albans.

In 1660, General George Monck's soldiers caused damage to the gates, although they were soon repaired with the following inscription affixed: 'This gate was repaired, beautified, and the foot postern new made at the charge of the City

Remains of a wall and bastion between Cripplegate and Aldersgate.

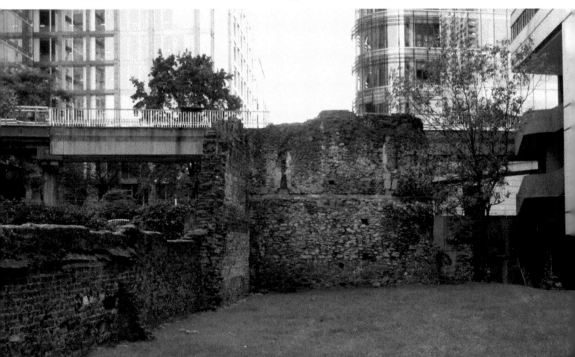

of London.' However, two years later it was reported that the building over Cripplegate has 'grown into great decay and ruin and often complained of as dangerous to passengers by the falling of stones'. Another three years passed and in 1665 the City records state: 'It is ordered that ye Gates of Cripplegate, being broken and decayed bee forthwith repaired and made good.'

Cripplegate had been used for executing and displaying the remains of criminals. One of the Wyatt rebels was 'hanged in front of Cripple Gate' on 15 February 1554. A radical sect that emerged in the ferment of Civil War in the 1640s was the Fifth Monarchy Men, who believed that the Second Coming of Christ was imminent. During the early years of the Restoration, a group of Fifth Monarchists decided to renew their war against the restored monarchy. After a bloody skirmish the usurpation was put down and brutal punishments were meted out to the

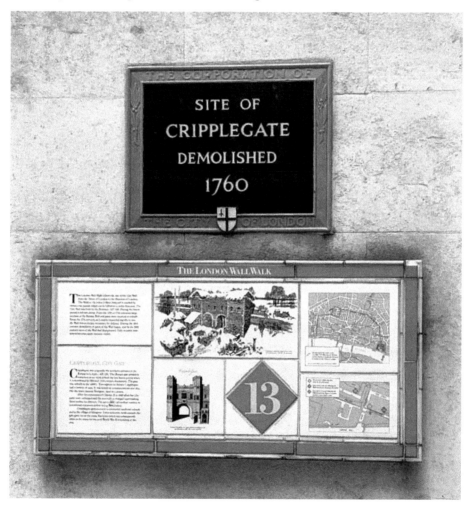

Plaque denoting the location of Cripplegate and a London Wall Walk information board. (© Museum of London)

rebels. Two of those executed, John Elson and William Corbet, had their quarters displayed on the gate.

In December 1759, the Court of Common Council referred the future of Cripplegate to the Committee for Letting the City's Land. They considered how 'far the City's Tolls might be affected by taking down the said Gates' and added that in the case of Aldgate and Cripplegate 'both of which appeared to be ancient Buildings with apartments over them ... upon inspecting the said apartments they found them so much out of repair that it would require a large sum to put them into a proper condition and would be attended with a frequent expense to keep them so'. Despite objections to the removal of the gate it was felt that the expense of collecting the few remaining tolls was too great and the rent too small to justify their continuance.

The following year the City Lands Committee advertised for tender to take down and remove the gates. Mr Benjamin Blackden, a carpenter in Coleman Street, bought Cripplegate for £91 and paid the same sum for Aldersgate.

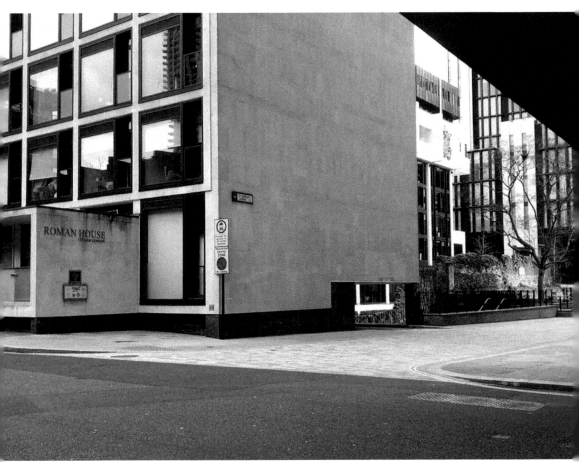

Cripplegate, 2020. The plaque is on the left and St Alphage Gardens is on the right.

5

Moorgate

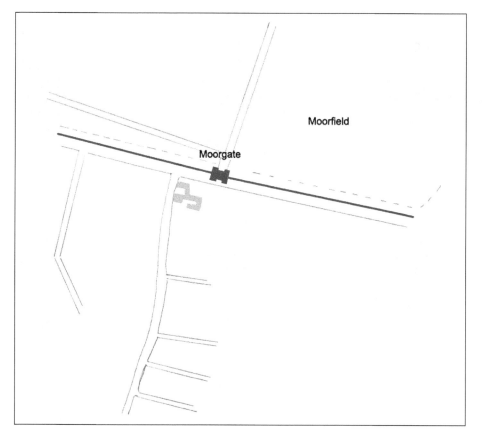

Map of Moorgate.

Moorgate, built in 1415, was the most recent of the seven gates. Its name is less ambiguous as it aptly describes the extent of marshland north of the City wall.

The construction of public buildings often relied on the bequests of individuals such as Thomas Falconer and Richard Whittington. In 1415, a commission from

Lord Mayor Thomas Falconer ordered that the postern near the end of Coleman Street be broken down and a new and larger one be built to the west with a 'gate to be shut at night and other fitting times'. This gate was 'made for the ease of citizens that pass into the field for their recreation' and to provide access to the open air of Moorfield. The extended postern became Moorgate and was further enlarged in 1472 and 1511. A causeway was built in 1415 from the new gate, which divided Little Moorfields on the west and Moorfields to the east.

The marshland prevented further northward expansion for many years – hence the focus for development was to the west. The Romans had attempted a land reclamation programme during the late first and early second century, which meant the wall and defensive ditch were not built until a century later. In addition, the area north of the wall was liable to flooding.

We know from excavations that the Romans used the area beyond the wall as a cemetery up to the late fourth century, notably east of what is now Finsbury Circus. However, the area eventually became a dumping ground. In 1211, another ditch, as well as the Roman one, was dug outside the wall to defend the City and drain the marsh. This huge ditch produced large amounts of brick earth, which was used on the marshland to reduce the flooding.

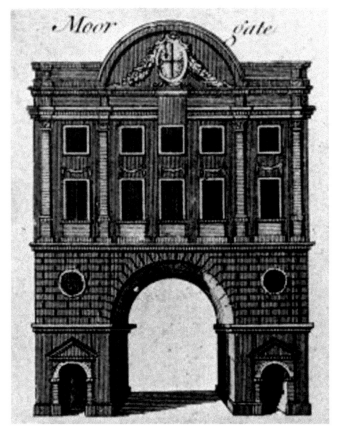

Seventeenth-century Moorgate. (Ditchfield, *Memorials of Old London*, 1908)

Archaeological evidence of a tanning pit showed that leatherworkers worked and lived here. In 1365, they were ordered by the Pelterers Guild to utilise the area to the north of the City around the Walbrook, and further attempts to reclaim the land were pursued from the fifteenth century. The area was used for winter skating (skates crafted from animal bones) or quarrying brick earth for repairs to the City wall.

In the mid-sixteenth century, Henry Martyn recorded in his diary that drowning was a regular occurrence in the ditches, especially among revellers trying to make their way home from 'the attractive ale gardens' before the gates closed. By the eighteenth century, Moorfields was characterised by poor houses, a reputation for brothels and for harbouring criminals. The area also hosted occasional open-air markets and shows.

Moorgate was considered to be one of the most magnificent gates of the City, with its various adornments, City coat of arms and apartments over the gates. Writing in 1708, Edward Hatton described the rebuilt gate as:

[a] lofty building of stone, adorned with pilasters, entablature and circular pediment, enriched with festoons, the north and south sides being uniform; but on the north side is this inscription: Begun in the year 1673. Sir Robert Hanson then Lord Mayor. Finished in the year 1674 ... here are also 2 foot posterns, one on each side of the gate ... There is nothing remarkable in the gate.

Although Moorgate escaped destruction from the Great Fire, the gate was so dilapidated it had to be rebuilt. The gate was more spacious than the others, giving it a more impressive and imposing entrance. Posterns were on each side of the arch for foot passengers and the rooms, as with the other gates, belonged to City officers. Strype adds that 'of late [early eighteenth century] it was made use of by a coffee-man', or coffee house. The gate was later raised with a 'lofty arch' so that the Trained Bands could march through with their pikes upright. Trained Bands used the new artillery ground nearby, although other writers have suggested that the height of the gate was meant for the greater convenience of bringing loaded carts or wagons of hay into the City.

The area north of Moorgate gradually changed and drainage was achieved by dumping rubbish to raise the ground. Moorfields was a garden to the City, for citizens to walk and take the air. A map of Moorgate and Moorfields from the mid-sixteenth century shows the range of activities taking place, including clothworkers using it as drying grounds with their wooden frames (or possibly tenters using it to stretch their cloth), people are engaged in archery, others are walking, and there are animals grazing.

Moorfields was eventually transformed. In 1730, Robert Burton wrote: 'These fields, which before were an unhealthy place, were turned into pleasant walks ... with trees for shade and ornament, compassed with brick walls.' However, the largest development came later when Finsbury Circus was laid out. By this time

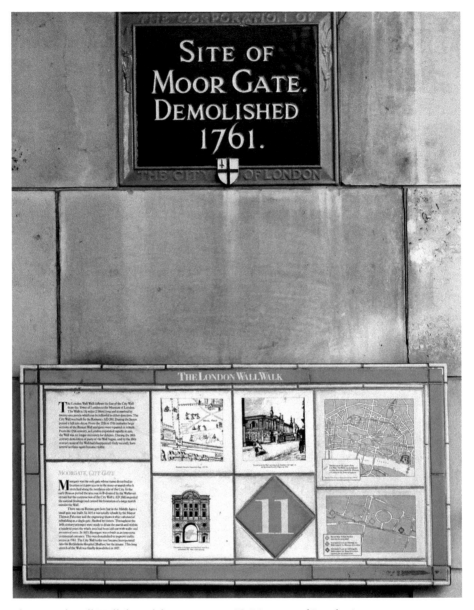

Plaque and Wall Walk board for Moorgate. (© Museum of London)

the gate had been condemned (1761) and demolished (1762) and its stone sold for £166 to the City of London Corporation, who used it to support the newly widened centre arch of London Bridge. As the development of London continued, the wall was dismantled over the next century. A blue plaque now marks the site of the gate at the southern end of Moorgate (No. 72), on the south-eastern side, at the junction with London Wall.

Bishopsgate

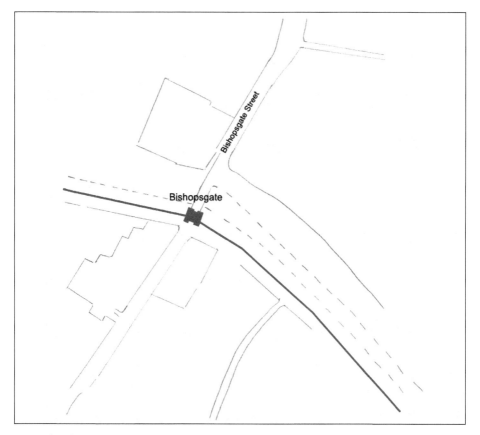

Map of Bishopsgate.

Located to the north-east of the wall, Bishopsgate was one of the original Roman gates. The Roman road of Ermine Street (from the Old English Earninga Street, 1012) ran via Bishopsgate from the Basilica Forum in the City to Lincoln and York. Although the name of the gate is debatable, it is believed to derive from when it was rebuilt in

the seventh century and named after Erkenwald or Eorconweold, Bishop of London (d. 685). It is referred to as '*Ad portam episcopi*' ('gate of the bishop') in the Domesday Book (1086). Stow notes that this gate was first built for the 'ease of Passengers toward the East and by the North; as into Norfolk, Suffolk, Cambridgeshire etc'.

There is little archaeological evidence of Roman settlement in the area beyond the wall as this was the eastern Roman cemetery. After the cemetery fell into disuse the site appears to have been used for agriculture, followed or accompanied by medieval rubbish pits and cesspits. By the eleventh century the area north of the gate was used variously for burials, refuse disposal and housing.

In 1260, Henry III granted the German Hansa merchants privileges by allowing their goods to be free from tolls as long as they kept the gate in repair and provided men to defend it when necessary. Wheatley notes that after some dispute it was agreed that 'the Merchants … shall be free from paying two shillings on going in or out of the gate of Bishopsgate with their goods, seeing that they are charged with the safe keeping … of the gate'. True to their word, they rebuilt the gate in 1479 and 1551.

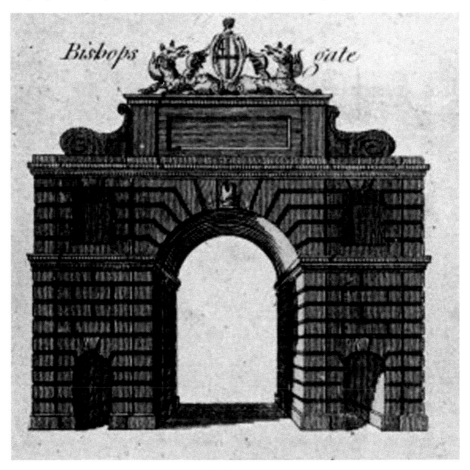

Seventeenth-century Bishopsgate. (Ditchfield, *Memorials of Old London,* 1908)

The Hanseatic League was a German merchant community who established storehouses in London from the thirteenth century. They dominated commercial activity in northern Europe from the thirteenth to the fifteenth century, and their influence on London was significant. They imported wheat, ropes, masts, tar, linen cloth, wax and wainscots as well as other merchandise. They were a truly international trading company.

Robert Burton, in 1730, noted that over the gateway on the south and north sides 'are figures in stone of some antiquity ... being probably as old as the gate itself, that is 240 years and more'. He added that a stone figure of a bishop on the south side stood high with 'a long beard, eyes sunk, and an old mortified face [and a] mitre on his head ... both hands [were] beat or worn off by time'. On the north side of the gate 'over the cart passage' was another large stone figure of a bishop giving a blessing with two fingers. It was thought that these were bishops of London, one being William the Norman ('the Conqueror's favourite') and the other Erkanwald.

Plaque commemorating the Hanseatic League on the Thames Path.

In addition to these stone figures were the City arms and several enrichments, including two ancient statues believed to be King Alfred and some great nobleman, possibly Aeldred, Earl of Mercia. There were rooms allotted to City officers – at least one was for the sergeant of the chamber. The gate was repaired in 1648 and rebuilt in 1731 in a plainer form – the only ornamentation being a pediment over the arch. Bishopsgate retained much of its medieval appearance apart from the addition of two pedestrian arches at the base of the tower and the removal of the battlements.

Densely packed tenements lined both sides of Bishopsgate by the fourteenth and fifteenth centuries, as well as large, elegant town houses on the frontage. Among these was the magnificent estate of Sir John Crosby, built in 1466 and described by John Stow as 'very large and beautiful and the highest at that time in London'.

By the late sixteenth century a dense network of lanes and alleys developed. Bishopsgate Without was paved in 1582 between the gate and the City bars. As the flow of traffic coming in and out of the gate increased, so did the number of inns. Outside the wall over 300 inns and brothels could be found, along with bull- and bear-baiting rings, and skittle and bowling alleys. Inns close to the gate included The Angel, Black Bull, Catherine Wheel Inn, The Flower Pot, Green Dragon, The Four Swans, Magpie and Punchbowl, and The Wrestlers.

The Bull Inn, also near the gate, was the scene of a planned mutiny in April 1649, when Parliamentary soldiers refused to fight in Ireland unless their own demands were met. The White Hart Inn, located north-west across from the gate, claimed to be the oldest inn in the area, dating from 1480. The Dolphin Inn, described as an old inn, very large 'and of good receipt', was on the opposite side, to the north-east.

In this expanding milieu north of Bishopsgate was Shoreditch, which became the bohemian haunt of Elizabethan London, and a place where Shakespeare lived and worked. He would probably have passed through Bishopsgate or Cripplegate from his later residence in Silver Street to the theatre in Shoreditch. Thomas Hugo, in his *Walks in the City* (1857), wrote of the 'overhanging Elizabethan gables and stately Caroline facades, varied masses of pleasantly mingled light and shade, frequent churches and sonorous bells'.

From the sixteenth century the area became a popular suburb enjoyed by Elizabethans for recreation and entertainment and as a garden suburb within easy reach of the City. Wealthy citizens developed properties on land outside the wall, acquired from St Mary Spital, Holywell Priory or Charterhouse.

The Venetian ambassador described Bishopsgate Without as 'an airy and fashionable area … a little too much in the country'. More houses appeared on both sides of Bishopsgate Street, including the Elizabethan mansion, Fisher's Folly, built in 1567 for Jasper Fisher, the warden of the Goldsmiths' Company. Another impressive mansion built around 1599 was that of Sir Paul Pindar (1565–1650), a merchant and ambassador of James I to the Ottoman Empire. Pindar bought several properties on the west side of Bishopsgate Without.

Outside the gate to the north-west of Bishopsgate Street stood the Priory and Hospital of St Mary Bethlehem, founded in 1247 on the site now occupied by Liverpool Street station. Bethlem Hospital, or 'Bedlam', as it became known, began as a religious order. From the fourteenth century it became one of the world's oldest hospitals, specialising in mental illness. As churchyards rapidly filled, the governors of Bethlem Hospital sold an acre of land in 1569 to the City officials to deal with the overflow. Bedlam became the most diverse graveyard in the City for radicals, Nonconformists, migrants, criminals, misfits, the mentally unwell and the working poor.

From 1197 to the north-east of the gate stood St Mary Spital, an Augustinian priory and hospital that was demolished in 1539. All Hallows-on-the-Wall, as the name suggests, is located inside and adjacent to London Wall. Its origins lay in the early twelfth century and it became well known for hermits who lived in cells in the church. Despite surviving the Great Fire, it was replaced in 1767 by the present church.

St Boltolph's Church stood just outside the gate to the north-west. The original Saxon church, first mentioned in 1212, was repaired in the sixteenth century via the benevolence of Sir William Allen, Lord Mayor (1571–72). Although

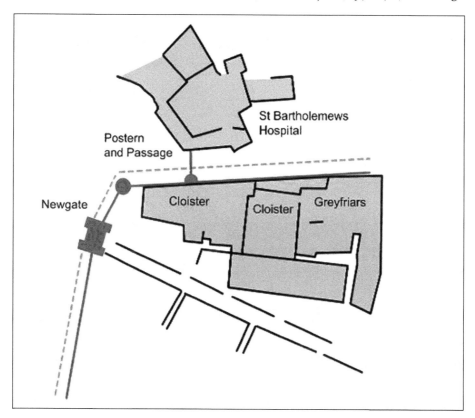

Postern passage.

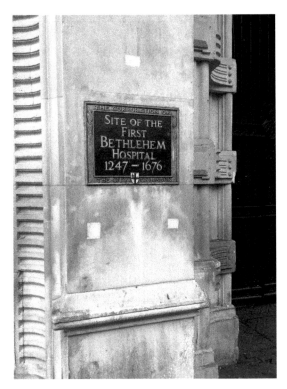

Site of Bethlem Hospital, Great Eastern Hotel, outside Liverpool Street station.

the church survived the Great Fire, it was demolished in 1725 and the present church was completed in 1729. Within the wall and to the south-east of the gate, is the church of St Helen's Bishopsgate, a Benedictine convent dating from the early thirteenth century and dedicated to St Helena, the mother of the Roman Emperor Constantine. St Helen's is the largest surviving parish church in the City of London.

A growing population in the thirteenth century created a demand for the supply of water. Wooden pipes brought in fresh sources from Tyburn in 1247, and in the fifteenth century a further supply was obtained from Paddington. Conduits and cisterns were located close to the gates at Newgate, Moorgate and Bishopsgate, although many of the conduits had been removed before 1720 as they had become a hindrance to traffic.

Just outside the wall between Bishopsgate and Aldgate (according to Stow a distance of '86 perches' from gate to gate – one perch equalling 16 ½ feet) ran the City ditch – a rubbish tip. Many unsuccessful attempts had been made to prevent the ditch becoming a dumping ground for all sorts of detritus, including dead dogs. Excavations in 2007 revealed the medieval ditch, which was some '17–20 m wide', with large deposits of refuse found. From the late fifteenth century to the mid-seventeenth century, 'the city ditch ... underwent a fairly rapid process of infilling as it fell out of use' and was eventually turned into gardens.

A significant expansion of both residential and commercial developments continued in the eighteenth century. The gate came to an end in 1760. The site is marked, unlike the other gates, not with a blue plaque but with a bronze bishop's mitre, at the junction of Bishopsgate and Wormwood Street on the wall of Boots.

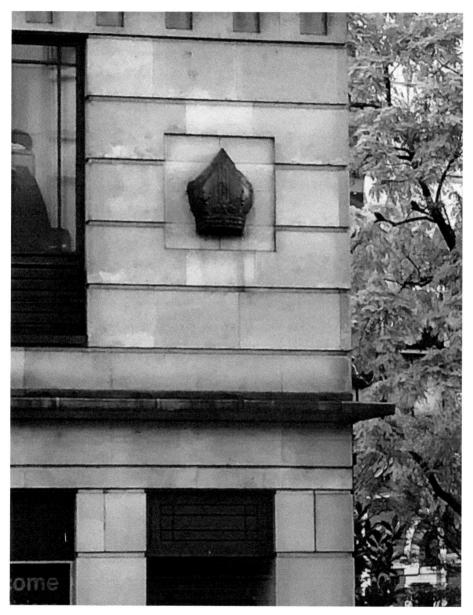

Bishopsgate Mitre above Boots.

Aldgate

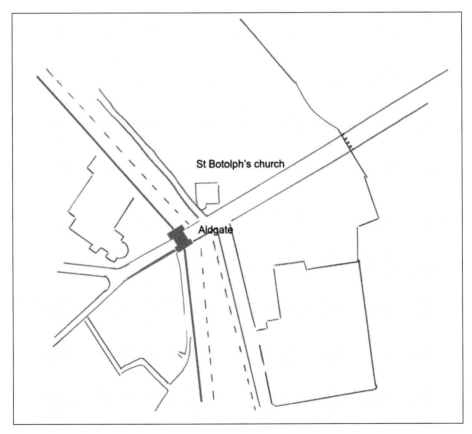

Map of Aldgate.

Aldgate was the easternmost gate into the City, and one of the original Roman gates. The etymology of Aldgate is disputed, with some (such as Weinreb and Hibbert) arguing it means 'old gate', while others (such as Kent) rejecting this idea. There seems to be general agreement that the gate was first referred to in

1052 by the Saxons as Æstgeat – *æst* being the Old English for 'east' and *geat* meaning 'gate'. In 1108, it was referred to as Algate or Alegate, probably denoting a place where ale was sold and consumed. By the thirteenth century it was known as Alegatestrete. Kent says that the name Aldgate does not occur until 1486–87.

A plaque outside Boots on Aldgate High Street, at the corner of Jewry Street, marks the location of the gate. Archaeological excavations in 1907 discovered the remains of a medieval foundation of an old gate on the south side of Aldgate High Street. A survey in 1998 in the cellars between Nos 87–89 Aldgate High Street and No. 37 Jewry Street showed evidence from the Roman to the post-medieval periods that Aldgate was a main thoroughfare from the City of London to Colchester. Although the precise location of the Roman gate is uncertain, it is believed to have straddled along part of Aldgate High Street with its southern edge at Nos 88–89 'suggesting that it only had a single entrance' (Bishop). The gateway was rebuilt between 1108–47 and 1215 and completely reconstructed again between 1606 and 1609 in a more classical style before being removed in 1761. The gate was a large structure that once had two portcullises, but by the late sixteenth century had only one.

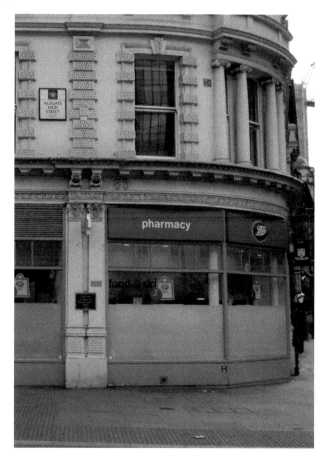

Sign outside Boots on Aldgate High Street denoting the site of Aldgate.

In the period between 1215 and 1606 the gate was breached at least three times. The First Barons' War (1215–17) was an attempt by major landowners (led by Robert Fitzwalter with a French army) to wage war on King John, who had refused to accept and abide by the Magna Carta. In May 1215, the barons entered London through Aldgate on their way to meet the king. Londoners assisted the barons, which may partly explain why the gate was conveniently unprotected. Stow comments that the barons came by night to London and 'entered Aeldgate' and 'placed guardians or keepers' on it. They then proceeded to 'dispose of all things at their pleasure', including friars' houses. The barons then 'applied all diligence to repair the gates and walls', with the stones taken from the broken houses of the Jews, 'Aeldgate being the most ruinous'.

Other assaults on Aldgate came in 1381 and 1471. The first was during the Peasants' Revolt, caused variously by tensions following the Black Death, high taxes and instability. Rebels from Essex advanced towards Aldgate and the City, with their entry made easier by the gate being left open. Aldermen Walter Sibil and William Tonge were accused of opening the gate and giving the rebels free entry into the City.

In 1471, Thomas Neville, 'the Bastard of Fauconberg' (1429–71), supported the Earl of Warwick's attempt to reinstate Henry VI. On 14 May, Fauconberg arrived at Aldgate and demanded to be let into the City. Aldgate came under sustained attack, 'with mighty shott of hand Gunnys & sharp shott of arrowis'. Some of the attackers managed to enter the City, but the Londoners let the portcullis drop and trapped their assailants inside. Alderman Robert Bassett ordered the portcullis to be drawn up and the rebels were driven back. The attack turned into a rout, with Neville and his army pursued as far as Stratford. The rebels had failed and, while some evaded capture, many were summarily executed.

It was during the 1381 uprising that Aldgate had its most famous resident. Geoffrey Chaucer (*c.* 1340–1400) lived in apartments above Aldgate from 1374 to 1386 while he was a customs official. Chaucer's maternal grandfather had been murdered close to his house in Aldgate in 1313.

The mayor and aldermen had granted 'the whole dwelling-house above the Gate, with chambers thereon built and a cellar beneath the said gate, on the eastern side ... together with all its appurtenances, for the lifetime of Geoffrey Chaucer' (Coulton). No rent was extracted, although he was expected to keep it in repair. A typical rent, per annum, would be around 13s 4d. Ralph Strode, a legal officer and a friend of Chaucer's, was paying this sum while lodging at Aldersgate. The City promised that no prisoners were to be kept during Chaucer's tenancy, but stipulated that possession would be resumed if and when it concerned the defence of the City.

Despite its description as a mansion, it was not luxury accommodation. Paul Strohm, in his book *The Poet's Tale* (2014), speculated on whether Chaucer had a single room or more: 'His predecessor's lease in fact refers to the dwelling in the singular and in its military sense, as one turret (*una turrela*), a single tower on the

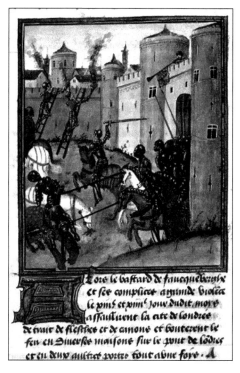

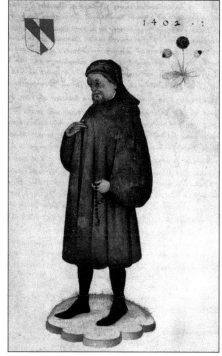

Above left: Thomas de Fauconberg's attempted attack on London in 1471 was repelled by Edward IV and his troops. (MS 1168 at the Besançon, from the French Ministry of Culture)

Above right: Geoffrey Chaucer – from a sixteenth-century portrait.

Right: Early Aldgate. (Ditchfield, *Memorials of Old London,* 1908)

south side of the gate. We may suppose this was Chaucer's dwelling as well.' His room allowed him access to the tower's crenellated roof, from which he would have seen St Botolph's Church immediately to the east and possibly St Paul's to the west. Coulton suggests that Chaucer's years at Aldgate were possibly his happiest. They

were very productive literary years in which he wrote *The Parliament of Fowls*, *Troilus and Criseyde* and translated *The Consolation of Philosophy* by Boethius.

On the day after Chaucer left his room in Aldgate a fresh lease was granted to his friend, Richard Forster. No doubt Chaucer was well placed for inspiration surrounded by a busy, robust, noisy and lively environment.

Another writer who lived in Aldgate was John Stow (1524–1605), who wrote a series of chronicles of English history but is most famous for *A Survey of London* (1598). He lived close to the Aldgate pump, not far from the gate. While at Aldgate he witnessed the execution of the bailiff of Romford, who was executed opposite Stow's house on the dubious basis that he took part in Kett's Rebellion (1549). Stow wrote that he heard the last words of the prisoner 'for he was executed upon the pavement of my door where I then kept house'. In 1570, Stow moved to the parish of St Andrew Undershaft, where he lived until his death in 1605.

Illustration of Aldgate showing rooms above the gate.

A year after Stow's death the construction of a new gate began in 1606. This gate was ornamented with two Roman soldiers on the outer battlements with stone balls in their hands, ready to defend the gate. Beneath them was a statue of James I with royal supporters at his feet. On the City side of the gate stood a large figure of Fortune, while lower down were figures of Peace and Charity, copied from two Roman coins. Ben Jonson referred to these figures in *The Silent Woman*: 'How long did the canvas hang before Aldgate? Were the people suffered to see the City's Love and Charity, while they were rude stone, before they were painted and burnished?' On the north side of the arch was a postern for foot passengers. Over the gate was the dwelling house of one of the mayor's carvers, who was also one of the Sergeants of the Chamber. The whole structure took over two years to build.

Aldgate Street was a main route in and out of the City. The street was once home to inns and taverns accommodating travellers coming to the City. Only a few remnants of the medieval buildings still exist. To the west of the gate was Holy Trinity Priory, founded in 1107 by Queen Matilda. It was the first religious house

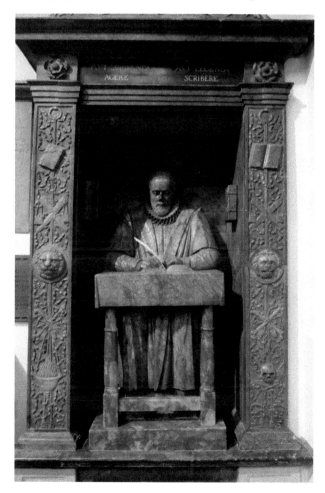

John Stow memorial, St Andrew Undershaft. Every three years a ceremony is performed when the quill in his hand is replaced.

to be built inside the walls of the City after the Norman Conquest. The priory was dissolved in 1532, but remnants of an arched section of wall can be viewed inside the building on the corner of Mitre Street and Leadenhall Street. To the immediate east of this is Mitre Square, which occupies the site of what was the cloister. There

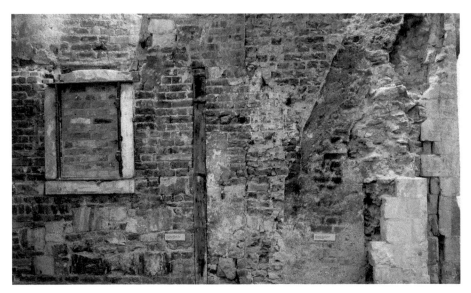

Above: Remains of Holy Trinity Priory from inside No. 77 Leadenhall Street.

Below left: Remains of an arch from Holy Trinity Priory.

Below right: Plaque to Holy Trinity Priory in Mitre Square – the site of the old cloisters.

was a hermitage on the south side of Aldgate built into London Wall by John the hermit in the thirteenth century.

Another nearby landmark is St Botolph-without-Aldgate. The original Anglo-Saxon church was enlarged in 1418, rebuilt in the 1500s, demolished in the eighteenth century and rebuilt again. Daniel Defoe was married in the church in 1683. Another building, the Monte Jovis, dates from 1195 and was founded by Henry II as a cell to the Hospital de Monte Jovis. The building was described as a fair and large house, formerly the prior's townhouse. Close to the gate was the usual crop of drinking places, such as The Crown Inn to the north-east, next to St Botolph's Church and The Three Nuns, a busy coaching inn known for its punch; The Pye was one of the oldest inns where plays were performed; and The Northumberland Inn was acquired in 1426 by Henry Percy, Earl of Northumberland, and held by his successors until 1474 when it was granted to others. In the early fifteenth century the Saracen's Head stood within a few yards of the gate. The Hoop and Grapes on Aldgate High Street has foundations going back many centuries, and in the cellar of the nearby Three Tuns public house a section of the wall is exposed.

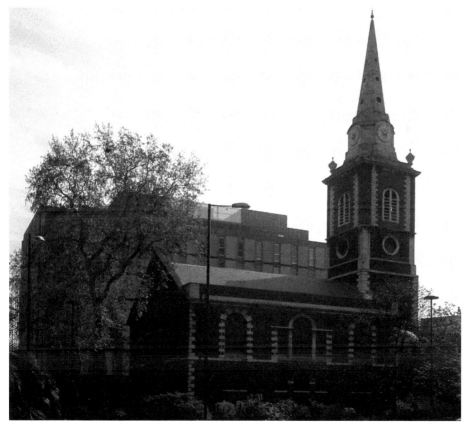

St Botolph-without-Aldgate.

Outside Aldgate, running south to the Tower, is Minories, established on the east side of the present street and named from the former Abbey of the Minoresses of St Clare-without-Aldgate, an order founded in 1294. The house was dissolved in 1538 and its place was taken by large storehouses for armour and 'habiliments of war'. Even by the early eighteenth century Minories was associated with gunsmiths and armourers.

The north end of what is now Jewry Street was adjacent to the City gate. Old Jewry (as it was) had become a centre for the Jewish population of medieval London, and it was close to here that the Great Synagogue stood. The synagogue was closed in 1271 and shortly after in 1290 the Jews were expelled from England until their readmission in the 1650s. In 1698, they settled once again in the area marked by London's oldest synagogue, at nearby Bevis Marks.

Aldgate survived the Great Fire and prisoners of the Poultry Compter were lodged there until the Compter could be rebuilt. Ten years before the gate's removal the rooms over it were being used as a charity school. In 1760, Aldgate was dismantled and the materials were sold for £177 10s. William Blackett of Wallington, Northumberland, bought some of the decorative portions for Rothey Castle. Antiquary Ebenezer Mussell of Bethnal Green bought a section of the gate,

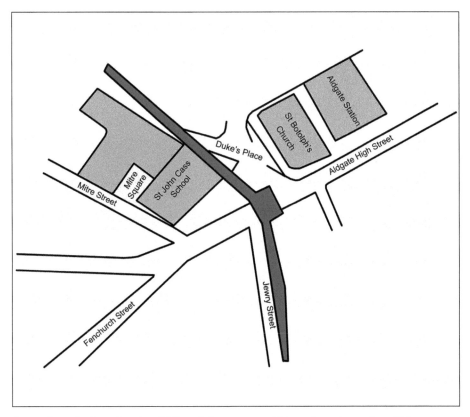

An outline of where London Wall and the gate would have been located at Aldgate.

Aldgate High Street.

which he then rebuilt on the north side of his mansion, Aldgate House. Aldgate House, built by Sir Thomas Goldsborough in 1643, stood on the east side of the green. It was described as a 'noble mansion ... the most antique and valuable part of Aldgate consisting of Runic, Saxon, Danish, Norman and English bricks'. Shortly after his acquisition, Mussell died (in 1764) and the house passed to his widow. Aldgate House was pulled down in 1809.

Other Gates

We have focused on the traditional gateways in the London Wall. This section of the book looks at other entrances to the City, such as bars, posterns and London Bridge, the latter of which Stow described as of equal importance to the other main gates. As the City expanded during the medieval period its boundaries ceased to coincide with the old wall. The area outside the wall, the Liberties, became incorporated into the City's jurisdiction. We are not sure when this precisely happened, but the boundaries were established shortly after the

City of London dragon, Aldgate.

Norman Conquest. Since the seventeenth century a pair of dragons have been part of the crest of the City of London on its coat of arms. Ornamental boundary markers were erected in the nineteenth century at points of entry into the City, each surmounted by a cast-iron silver dragon on stone plinths clutching a heraldic shield. The section finishes with a brief discussion on water gates, most of which were landing places.

The Bars

The old gates served various functions, whereas bars, posts or chains on a major road mainly marked the new boundaries, the most well known being Temple Bar on Fleet Street. The City bars were situated beyond the old walled area, such as at Holborn, Aldersgate, West Smithfield and Aldgate. These were important entrances to the City and their control was vital in maintaining the City's special privileges over particular trades. Stow comments on the importance of these bars, but does not elaborate on the detail for most of them. An expanding population began to crowd the area between the City gates and the bars of the Liberties, so proclamations were made in 1580 forbidding any building within 3 miles of the City gates. This was intended to act as a buffer against the plague and to preserve farmland near the City.

To the west of Newgate stood the Holborn Bars, which marked the termination of the City Liberties in that direction. First referred to as the 'Bar of Holeburne' and variously as 'Bar of Old Temple' and 'Holburnbarre', they were originally set up around 1130. Tolls and dues were taken, with the Corporation of London receiving 1*d* and 2*d* toll from the carts and carriages of non-freemen entering the City. In addition, guards prevented the entry of vagabonds, rogues and lepers.

Kent, in his *Dictionary of London*, discusses the derivation of nearby Staple Inn and suggests that it is connected with a post or bar, which is consistent with the present boundary. The *Oxford English Dictionary* agrees, but adds the old French *estaple*, denoting a place or market for selling wool. The bars were removed in the eighteenth century and replaced with stone obelisks. In his account of Staple Inn, Thomas Cato Worsfold (1913) described the roads around Holborn Bars as a nuisance until 1541 when a statute was passed 'ordering certain streets to be paved with stone in view of their being very foul and full of pits and sloughs, very perilous ... for the King's subjects on horseback as on foot and with carriages'.

To the east and close to the Holborn Bars was Furnival's Inn, founded in 1383 when Lord William de Furnival leased a boarding facility to the Clerks of Chancery. In 1548, it was affiliated to Lincoln's Inn. Opposite Furnival's Inn stood Barnard's Inn, which was also an Inn of Chancery and is now the home of Gresham College.

West Smithfield Bars stood to the north of Newgate and north-east of Aldersgate, just beyond Smithfield market. Up until the sixteenth century the bar

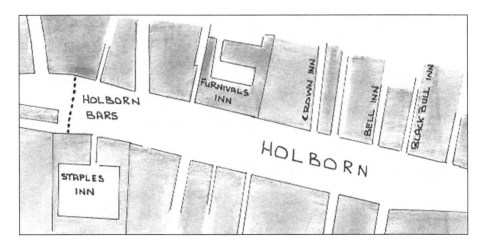

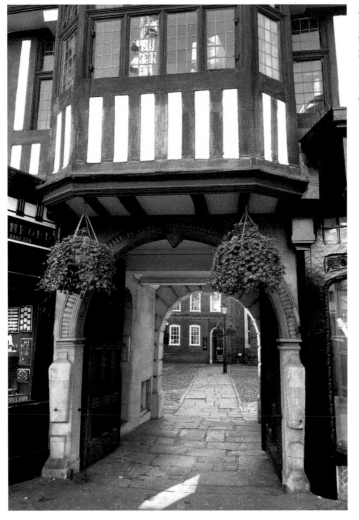

Above: Map of Holborn showing the location of Staple Inn.

Left: Staple Inn entrance.

was located in open fields, convenient for traders, drovers and livestock en route to the markets. William FitzStephen described Smithfield in 1174 as a 'celebrated rendezvous' where country traders came to sell cows, sheep, pigs and agricultural goods. A market had existed since the tenth century and the preeminent Bartholomew Fair, which took place every August, ran from 1133 until 1855. An early reference to the bars noted that in 1170 St John Street was the street 'which goeth from the bar of Smithfield towards Yseldon [Islington]'.

West Smithfield Bars were a short distance from the boisterous activities around the market and its surrounding environs. Smithfield was regularly filled with the roar of crowds. Regal fanfares, rowdy games and large public gatherings for the gruesome executions also took place there. The market, St Bartholomew's Hospital and St Bartholomew's Church were all well established by the twelfth century.

Aldersgate Bars were to the north of the gate. Maitland, in his *History and Survey of London* (1775), noted that Goswell Street (now Goswell Road) 'begins at Barbican, where Aldersgate Street ends, and runs up to the Bars in this Ward, and much farther Northward beyond Old-street'. He described the street as broad but meanly built and inhabited, 'especially beyond the Bars'. He added that within the bars are 'courts and places of note: Cock Inn has a good Trade, and has a large

Plaque to William Wallace, Smithfield.

Yard for Coach-Houses and Stabling'. He notes other inns too, such as the *Three Cups, White Horse* and *Red Lion*.

In 1575, twenty-seven Anabaptists were arrested in a private house 'without Aldersgate Bars' for heresy. Nine of them were banished and two suffered the 'extremities of the fire in Smithfield'.

To the west of Aldersgate Bars was Charterhouse, founded in 1371. It originated as a Carthusian priory until it was dissolved in 1537. During the Reformation six Carthusian monks of Charterhouse were executed for refusing the Oath of Supremacy, and ten of them starved to death in Newgate. Charterhouse was rebuilt in 1545 as a large country house. It variously passed from the dukes of Norfolk to Thomas Sutton (1532–1611), who bequeathed money to maintain a chapel, hospital (almshouse) and school. Damaged during the Second World War, Charterhouse continues to serve as an almshouse.

The Aldgate Bars marked the eastern limit of the City. They are referred to as either Aldgate or Whitechapel Bars because they were located at the western end of Whitechapel and the eastern end of Aldgate Street. The Agas map of 1561 shows them as two posts, one above the other, and are labelled simply as 'Barres'. Daniel Defoe (1660–1731), in his *Journal of the Plague Year*, wrote:

> I lived without Aldgate, about midway between Aldgate Church and Whitechapel Bars, on the left hand or north side of the street; and as the distemper had not reached to that side of the City, our neighbourhood continued very easy; but at the other end of the town the consternation was very great ...

During the plague of 1665–66, orders were issued stating that no stranger was allowed to enter the gates of a town unless they had a certificate of health.

The street leading from Aldgate to Whitechapel became so bad and impassable for carriages and horses that it was paved in 1572. The street had clearly improved and was more populated by the time Stow was writing. He commented that the main road from Aldgate had some tenements thinly scattered with much 'space between them, up to the said Barre, but now that streete is not only fully replenished with buildings [it] is also pestered with divers alleys on either side, to the Barres ... even to Whitechapel and beyond'.

Strype described the same street as:

> [a] spacious fair street, for entrance into the City eastward, and somewhat long, reckoning from the laystall [a place where rubbish and dung are deposited] east unto the bars west. It is a great thoroughfare, being the Essex road, and well resorted unto, which occasions it to be the better inhabited, and accommodated with good inns for the reception of travellers, and for horses, coaches, carts, and wagons.

As with the gates, a series of Acts in the 1760s saw improvements to the streets, which meant the clearance of what were seen as 'nuisances'. An Act of 1766 stated

that 'the streets that are first to be paved and enlightened are the great streets from Temple-bar to Whitechapel-bars'. Although many streets were improved, bars, such as Temple Bar, remained.

Temple Bar

Temple Bar (named after Temple Church) was located at the west end of Fleet Street. Most of this area, extending to what is now Farringdon Street, had been in the bounds of the City of Westminster. Why and when the area of Fleet Street became part of the jurisdiction of the City is uncertain. The authority of the City of London Corporation had, by the Middle Ages, reached beyond the ancient wall in several places.

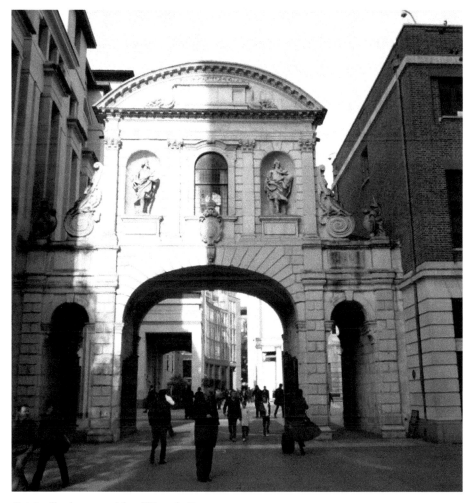

Originally the west side of Temple Bar.

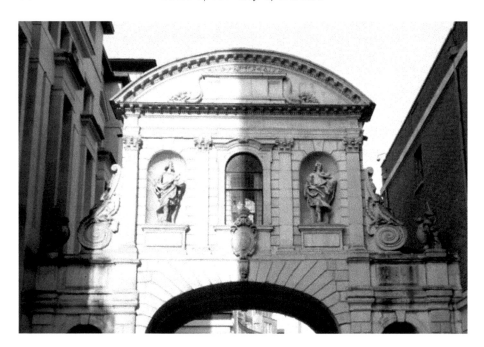

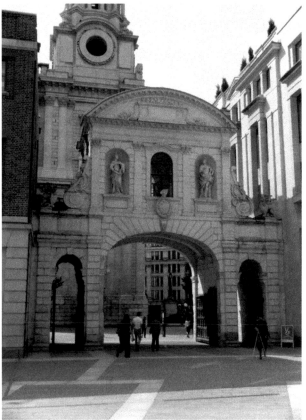

Above: The royal coat of arms and Charles I and Charles II in Roman drapery on the west side of Temple Bar.

Left: Originally the east side of Temple Bar.

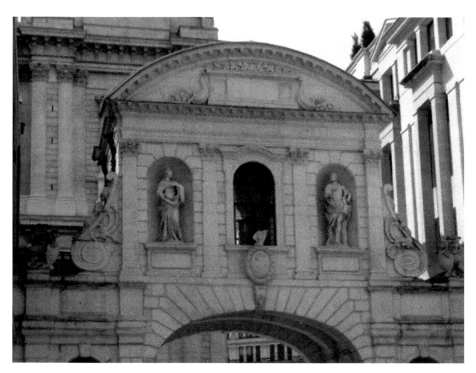

Elizabeth I and James I, the Corporation of London's coat of arms and the mayoral inscription. The heraldic dragons stand on each side of the east side of Temple bar.

A bar is first mentioned here in 1293, although this was little more than a chain or bar between two wooden posts. John Norden, in his *Speculum Britannia* (1593), noted that in 1381 on the occasion of Wat Tyler's (1341–81) rebellion, the gate 'was thrown down by the Kentish rebels'. This suggests that the bar was little more than a gate. Outcasts and lepers, forbidden to live in the City, crowded the area around Temple Bar, making it intimidating by their begging.

Temple Bar was a substantial structure and almost akin to the old City gates. Mann described it as a 'bulwark against attack and thus a symbol of the City's strength and independence'. The bar appears to have improved by the sixteenth century, when it was 'newly painted and repaired'. When Philip of Spain arrived in London in 1554 'a good and substantial new pair of gates' was ordered for the occasion. The bar's demarcation of entry into the City gave it significance and is mentioned with regard to receiving the marriage of Mary Tudor to Phillip of Spain and the funeral cortege of Henry VII's queen, Elizabeth of York. The triumphal procession of Elizabeth I after the defeat of the Spanish Armada (1588) was an occasion when Temple Bar was suitably decorated, with City minstrels congregated on the top as she stayed for a while beneath the archway. Elizabeth had stopped to meet the Lord Mayor, who presented her with the keys of the City, which she reciprocated by presenting the Lord Mayor with a pearl-encrusted sword (one of five City swords).

Although the Great Fire had stopped before it reached Temple Bar, the bar was in a state of disrepair. In July 1669, the Commissioners of Streets and Sewers proposed its removal in order to enlarge the street. As such, money was raised, which contributed to the building of a new Temple Bar.

Inigo Jones (1573–1652), the great architect, was invited to design a new archway for Temple Bar, but the scheme was never carried out. However, some years later Sir Christopher Wren reputedly designed the new Portland stone structure, which was completed in 1672 at a total cost of £1,500. It had all the appearance of being a regal monument with two stone statues – of Elizabeth I and James I – on the original east side of the gateway by sculptor John Bushnell, and statues of Charles I and Charles II on the west side. However, to emphasise the City's importance, over the keystone on the east side was the City arms and a mayoral inscription: 'Erected in the year 1670, Sir Samuel Starling, Mayor; continued in the year 1671, Sir Richard Ford, Lord Mayor; and finished in the year 1672, Sir George Waterman, Lord Mayor.'

Less decorative ornamentation were the heads and limbs of those executed for high treason. The Rye House Plot of 1683 was a conspiracy to assassinate Charles II and his brother James, Duke of York. One of the plotters, Sir Thomas Armstrong, was executed and had his limbs exhibited on Temple Bar. A few years later John Evelyn noted in his diary for 10 April 1696, regarding the plotters against William III, that the 'quarters of Sir William Perkins and Sir John Friend, lately executed … with Perkins head, were set up at Temple Bar, a dismal sight, which many pitied'.

In 1716, Colonel Henry Oxburgh, a Jacobite supporter, had his head placed on a spike at Temple Bar, although the head of Christopher Layer in 1723 holds an unenviable record. It was believed to have remained on display for thirty years before being blown down in a gale. Among the last victims to be exhibited were those who suffered for their complicity in the 1745 Jacobite Rebellion. Francis Townley and George Fletcher had their body parts displayed in 1746, and among the more macabre commercial activities was that of letting spyglasses out at a halfpenny a look.

During the 'Wilkes and Liberty' riots in 1769 the gates were closed when some 600 merchants, bankers and others opposing John Wilkes set out from the City to present an address to the king. However, the mob had closed the gates by force, thus preventing the deputation from proceeding. Not to be deterred, around 150 of the opponents managed to proceed up Chancery Lane and other routes and duly presented their address.

With an increase in both population and traffic during the nineteenth century, the Strand and Fleet Street became increasingly congested, so it was decided in 1878, after 200 years, to remove Temple Bar. The City of London Corporation was keen to widen the road, but did not want to destroy the historic monument, so it was dismantled stone by stone in the hope that it might be erected elsewhere. In 1880, the brewer Sir Henry Meux bought the stones with the intention of

Heads of Townley and Fletcher at Temple Bar. (W. Thornberry, *Haunted London*, 1880)

reconstructing the bar as a gateway to his park and mansion at Theobalds Park, Cheshunt, in Hertfordshire. Having witnessed so many eventful occasions, Temple Bar now stood in retirement in tranquil woodland surroundings.

In August 1880, the attorney general was asked in the House of Commons if he was aware that 'the Corporation of London are now preparing to erect, in the centre of one of the busiest parts of Fleet Street, an edifice to commemorate the site of Temple Bar?' Mr Firth, the questioner, also raised the issue as to whether such a monument would cause an obstruction. Sir Henry James, the attorney

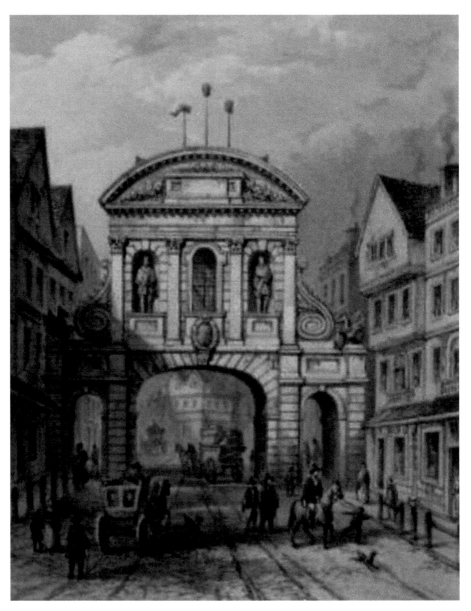

Temple Bar. (Wilson, *Temple Bar*)

general, stated that the 'Corporation intended to erect a refuge in the centre of the roadway where Temple Bar was formerly situated, and the effect would be that the roadway would form two roads 17 feet 2 inches wide.'

The monument that now stands opposite the law courts, where Fleet Street takes over from the Strand, marks the place of the old Temple Bar. Architect Sir Horace Jones designed the new Temple Bar and sculptor Charles Bell Birch (1832–93) created the heraldic bronze dragon on the top. The bronze

freestanding statues of Queen Victoria and the Prince of Wales are by Sir Joseph Boehm. Not everyone warmed to the new bar. London historian Beresford Chancellor commented that 'the removal of Temple Bar and the substitution of the ridiculous Griffin has taken from it its most picturesque landmark and added its most useless feature'.

The present memorial to Temple Bar on Fleet Street.

Flagstone in Paternoster Square commemorating the return of Temple Bar.

Meanwhile, the old Temple Bar gradually became dilapidated over the years, and in 1976 the Temple Bar Trust was established with the intention of returning the bar to the City of London. Twenty-eight years later, with financial contributions from the Corporation of London, the Temple Bar Trust and several livery companies, Temple Bar came home. In November 2004, it was officially opened by the Lord Mayor in its new position, adjacent to the north-west Tower of St Paul's Cathedral. It now forms a pedestrian gateway into the redeveloped Paternoster Square.

Posterns

A postern is defined as a back door or a gate and, according to Stow, there were 'several Land-Gates and Posterns through the Wall, built for Convenience of Passage into and out of the City'.

Map of a postern near the Tower of London.

In the Cripplegate area was Aldermanbury, an Anglo-Saxon name meaning 'the fortified residence of the alderman'. It gave its name to the present street and to the parish through which the street runs. Schofield and Dyson (*Archaeology of the City of London*, 1980) state that in the twelfth and thirteenth centuries the 'owners of this property held the church of St Mary next door to the south, while in the fourteenth century [both] house and church were directly linked by a postern'.

The area outside the wall had grown to such a degree that by the mid-seventeenth century that the gates of Moorgate and Cripplegate needed additional entrances

to cope with the amount of people passing in and out. Shortly after, in 1654, the Court of Common Council, the governing body of the City, added a third postern between the first two. This postern was originally called the 'Little Postern', but in later years was referred to as the 'Aldermanbury Postern'. Strype described the street and Aldermanbury Postern as a 'pretty handsome short street, well built, and inhabited; [it] hath a passage through London Wall, over against Aldermanbury and therefore so called'. During the Great Fire of 1666 people found these posterns of immense help as they fled the City to the safety beyond the wall. However, by the mid eighteenth century a petition was presented by people living within the area for the removal of the narrow Aldermanbury Postern because of the nuisance it was causing. A few years later the posterns facing Aldermanbury and Basinghall Street were removed and the 'passages made wide into Fore Street'.

Close to Newgate stands Christ Church Greyfriars. Stow noted a postern gate 'made out of the wall on the north side of the late dissolved cloister of ... Grey friars, now Christ's church and hospital'. This postern, made in 1553, passed from the hospital of Christ's Church into the hospital of St Bartholomew in Smithfield. Licence was given by the Common Council to the Lord Mayor and aldermen to break down as much of the City wall 'as should suffice' to make the passage.

In 1636, another part of the wall was broken down to make way for a postern between Bishopsgate and Moorgate, opposite what was Little Winchester Street. The postern, which was demolished by 1755, was made for the use of foot passengers going into Moorfields.

In 1979, excavations at Tower Hill uncovered the remains of the medieval postern gate at the junction of the City's defensive wall and the moat of the Tower of London. The postern, which was constructed between 1297 and 1308, was both a minor gateway for pedestrian traffic and a defensive terminus to the City wall. The results of the excavation is well documented by David Whipp (*The Medieval Postern Gate by the Tower of London*, 2006), who tells us that the remains 'survived because of a landslip in 1341 or 1440, when the southern part of the structure slipped at least three metres down the side of the moat ... Cartographic evidence shows us that a postern gate stood on the site until at least the early seventeenth century'.

Stow recorded this landslip and criticised the negligence of those who built it: 'Such was their negligence then, and hath bred some trouble to their successors, since they suffered a weake and wooden building to be there made, inhabited by persons of lewde life.' He adds that the postern 'is all taken down' and a few posts were set up to keep off carts and coaches as there was 'only a narrow passage for Foot-passengers there'.

Pepys records his visit on 20 May 1667: 'So away home, and then, I ... did walk abroad, first through the Minorys, the first time I have been over the Hill to the postern-gate and seen the place, since the houses were pulled down about that side of the Tower, since the fire.'

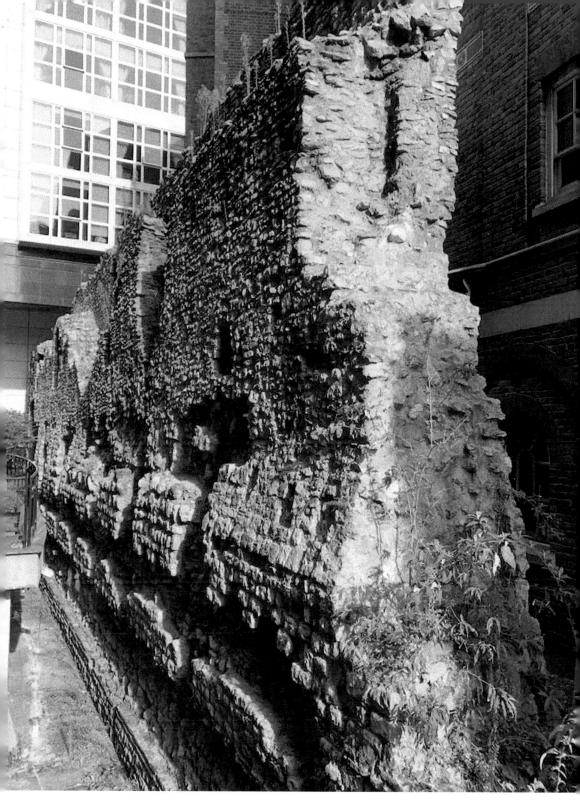

Remains of London Wall, Coopers Row, near the Tower of London.

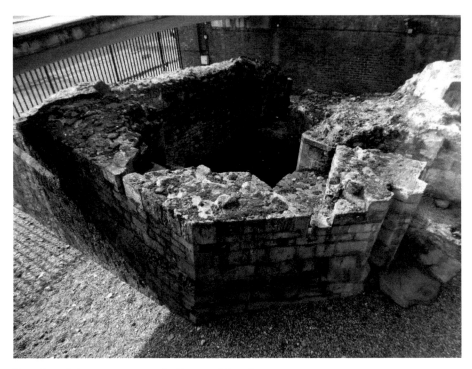

Remains of the postern near the Tower of London.

Adjacent to the postern was a descent by steps protected by a railing, which led down to what was called the 'Postern-spring'. In June 1763, a tragic event occurred when fireworks were set off on Tower Hill to commemorate the king's birthday. A large crowd had assembled but found themselves pressed against the railing, which gave way and a section of the crowd fell 30 feet into the spring. In all, twenty people were killed, and many injured. Remains of the postern can still be seen.

London Bridge – Bridge Gate

In his description of the gates of the City, John Stow wrote: 'Bridge Gate, so called of London Bridge, whereon it standeth … was one of the foure first and principall gates of the cittie, long before the conquest, when there stoode a Bridge of timber.' He adds that when the bridge was rebuilt of stone it had 'been often repaired'. In 1436, the gate and tower fell down, but was repaired with the financial help of wealthy citizens.

Much has been written about the history of London Bridge, but, in brief, a bridge from the City to the south is thought to date from AD 100. The first reference to a bridge in Saxon times is around 963–75 and records from the eleventh century note repairs to wooden structures. The first stone bridge was built between 1176 and 1209, surmounted by houses and shops, of which there

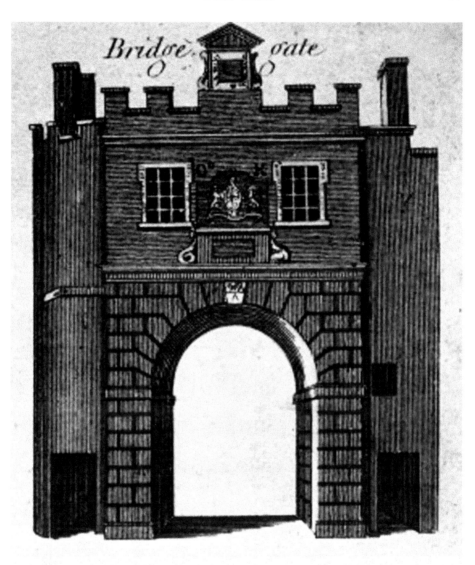

Bridgegate. (Ditchfield, *Memorials of Old London,* 1908)

were nearly 200 by the sixteenth century. Many of these either burned down or collapsed with subsidence. This bridge was to remain the only one in London until the mid-eighteenth century. The demand to cross the river was great and one bridge could not meet this hence people hired watermen or wherrymen to row them across or transport them up or down the river.

Over the centuries, Old London Bridge witnessed fire, siege, insurrection, pageants as well as some grisly exhibits. People entering the City would be met by the grisly sight of the severed heads of traitors and heretics placed on pikes and displayed for all to see. William Wallace's head is reputed to have been the

first to appear over the gate – in 1305 – starting a tradition that lasted until the 1670s. The gate at the Southwark end is referred to as the 'Great Stone Gate', while the gate at the City or northern end is referred to as the 'Drawbridge Gate'. Heads were displayed on the Drawbridge Gate between 1305 and 1577, and after 1577 they were relocated to the Great Stone Gate. This was a consequence of the Drawbridge Gate suffering from general wear and tear, not helped by the constant use of iron-shod carts. It was demolished and replaced by Nonsuch House in 1577.

In Anthony van den Wyngarde's drawing of around 1550, five heads can be seen on the Drawbridge Gate. Other accounts, such as *The Diary of the Duke of Stettin's Journey through England* (1602), recorded that at the southern side of the bridge 'were ... the heads of 30 gentlemen of high standing who had been beheaded on account of treason ... against the Queen'. One contemporary wrote in 1566 that heads on the bridge appeared like the 'masts of ships'.

In addition to the head of Wallace in this display of gruesome garniture, the gate also displayed those of Jack Cade and his rebels in 1451; Elizabeth Barton, 'the Holy Maid of Kent', in 1534; and Sir Thomas More in 1535. A high-profile execution was that of Bishop and Cardinal John Fisher (1469–1535), who was executed by order of Henry VIII for refusing to accept him as Head of the Church of England. Fisher was beheaded on Tower Hill on 22 June 1535 and his head was stuck upon a pole on London Bridge where sightseers clamouring to see it caused huge congestion on

John Fisher, Bishop of Rochester, with a decapitated head in the foreground. (By Jacobus Houbraken, 1760)

and around the bridge. The Keeper of the Heads was provided with regular work by disposing of the rotting heads and replacing them with new arrivals.

The river and drawbridge near the Southwark end were regarded as marking the boundary of the City's power on the bridge. Patricia Pierce, in *Old London Bridge* (2001), clarifies the question of ownership: 'the water of the Thames belonged to the City for some distance seawards. Twelve knights of Surrey agreed, giving the City rights over the whole length of the bridge.' It was the bridge wardens who took charge of the day to day running of the bridge.

London Bridge had nineteen piers and twenty arches, as well as the houses and gateways. Pierce describes the gate at the Southwark end as having ten shops on each side of it. The gateway had wooden gates and a portcullis overhead and a drawbridge, which was first mentioned in 1257. When raised, the drawbridge prevented any land attack. This gate is often referred to as 'Traitors Gate', not to be confused with the Traitor's Gate river entrance to the Tower of London.

Tolls were taken at the Great Stone Gate, and it was the responsibility of the collector to make sure the traffic flowed without hold-ups. Tolls varied depending on the size and weight of the freight. For every cart or wagon with shod wheels 4*d* was charged, and for loads in excess of 1 ton the toll was 2*d*, while those with less was 1*d*.

The houses were demolished in 1762, thus ending over 500 years of housing on the bridge. Old London Bridge continued in use while the new bridge was being built, and was then demolished after the new one opened in 1831. As with the

One of fourteen pedestrian alcoves from Old London Bridge. This stands in the courtyard of Guy's Hospital with a seated statue of John Keats.

The royal coat of arms above the Kings Arms, Newcomen Street.

traditional gates in the City wall, the Great Stone Gate, or what was left of it, was removed in 1760. A publican at a nearby tavern in what is now Newcomen Street (then King Street) bought the royal coat of arms that had adorned the southern gateway. When the pub was rebuilt in 1890 the coat of arms survived and can still be seen outside the Kings Arms.

Water Gates

When the London Wall was erected it was probably assumed that it offered sufficient defence of the City and that the Thames would act as a barrier from the south. Raids by Saxon pirates in the third century prompted the construction of a riverside wall, which began around AD 280. Excavations have shown that between the late third and the late fourth centuries a new wall along the riverfront connected the east and western ends, roughly between Upper and Lower Thames Street. Further excavations between 1976 and 2006 revealed sections of the river wall, suggesting that a continuous wall around 1,700 metres were constructed along the riverfront. Some parts were built in a similar way to the original City wall, using additional oak pile and chalk foundations. Richard Hingley notes

that 'the riverside wall completed a plan to enclose Londinium with a circuit of stone that took almost one hundred years of building … The riverside wall was constructed when the waterfront was no longer maintained, although it is possible that boats could be moored outside the wall at high tide'.

We have focused on the landward gates and entrances that allowed access into and out of the City. The water gates served the busy traffic in all types of trade. The old Roman waterfront wall was removed partly by tidal erosion, and deliberate

Timber piling from the Roman river wall dating to around AD 75 in St Magnus the Martyr Church's porch.

intent and much of it had long gone by the twelfth century. FitzStephen tells us: 'the ebb and flow of the Thames has in course washed away those walls, undermined and overthrown them'. For the first time since the third century the waterfront was opened up and gave way to the building of properties with private river stairs. Besides these water gates there were many wharfs and keys from east to west on the banks of the City. From the twelfth century merchants of many nations had landing places as well as warehouses and cellars for the storage of their goods.

John Stow pointed out: 'Water gates on the banks of the River Thames have been many, which being purchased by private men, are also put to private use, and the old names of them forgotten.' Included in his list are, Blackfriars, Puddle Wharf, Paul's Wharf, Broken Wharf, Wools Wharf, Downgate, Ebgate, Oyster Gate, Billingsgate, Wolfes Gate, Botolpshgate and Queenhithe, which Stow described 'as the very chief and principal water-gate of the City'.

The City was vulnerable from the river, and a system of protection was required. Some of the busiest traffic in London was on the River Thames, which was the main transport route for heavy goods. There was also a busy and regular service of small boats ferrying people back and forth across the river. Hence the need for these gates, as with the gates in the City wall, to be closed at night and guards keeping watch. Passage across the Thames at night was forbidden and sergeants of Billingsgate and Queenhithe, each with a boat and four men, kept guard on either side of the bridge. From the mid-thirteenth century it was deemed that the 'Ports of England should be strongly kept, and that the Gates of London should be newly repaired, and diligently watched in the Night, for fear of French Deceits'.

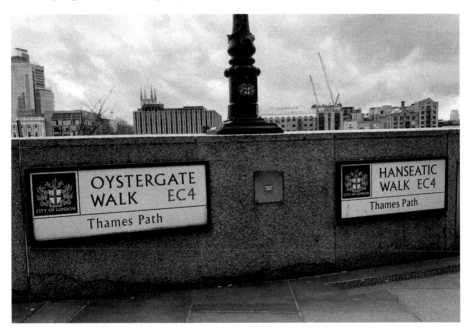

Oystergate Walk, along the River Thames, near London Bridge.

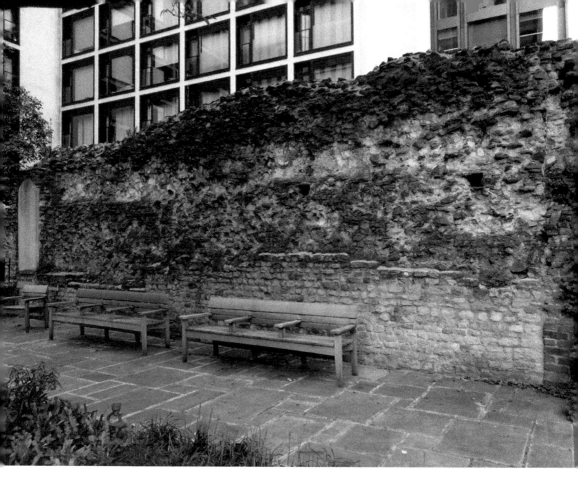

Above: Remains of
the city wall near
Cripplegate.

Right: Remains of
the city wall near
the Barbican.

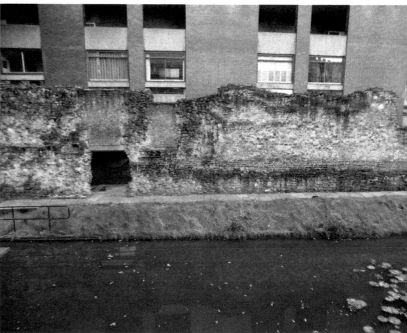

Bibliography

Books

Ackroyd, P., *London: The Biography* (Vintage: 2001)

Baddeley, J. J., *Cripplegate: One of the Twenty-Six Wards of the City of London* (London, 1922)

Brooke, A., *Fleet Street: The Story of a Street* (Amberley: Stroud, 2010)

Burton, R., *A New View and Observations of the Ancient and Present State of London and Westminster* (London, 1730)

Coulton, G. G., *Chaucer and His England* (London, 1908)

Denton, W., *Records of St Giles' Cripplegate* (George Bell & Sons: London, 1883)

Ditchfield, P. H. (ed.), *Memorials of Old London*, Vol. 1 (London, 1908)

Gordon, C., *The Old Bailey and Newgate* (London, 1902)

Harben, H. A., *A Dictionary of London* (London, 1918)

Hatton, E., *A New View of London*, Vol. 1 (London, 1708)

Hibbert, C. and B. Weinreb, *The London Encyclopaedia* (Macmillan: London, 2008)

Hingley, R. *Londinium: A Biography* (Bloomsbury: 2018)

Jones, E., A, *Hermits and Anchorites in England, 1200–1550* (Manchester University: Press, 2019)

Kent, K. (ed.), *An Encyclopaedia of London* (J. M. Dent: London, 1937)

Maitland, W., *The History and Survey of London* (1775)

Mann, Emily, 'In Defence of the City: The Gates of London and Temple Bar in the Seventeenth Century' in *Architectural History*, Vol. 49 (2006)

Merrifield, R., *London City of the Romans* (Batsford: London, 1983)

Mills, A. D., *Oxford Dictionary of London Place Names* (Oxford University Press: 2004)

Pierce, P., *Old London Bridge* (Headline: London 2001)

Schofield, J., *The Building of London: From the Conquest to the Great Fire* (British Museum Publications: 1983)

Sorapure, D., 'The Medieval Ditch at Bishopsgate' in *Transactions of the London & Middlesex Archaeological Society*, Vol. 67 (2016)

Stow, J., *A Survey of London* (Sutton: 1999)

Strohm, P., *The Poet's Tale: Chaucer and the Year That Made The Canterbury Tales* (Profile Books: London, 2014)

Thornbury, W., *Old and New London*, Volume 2 (London, 1878)

Timbs, J., *Curiosities of Old London* (London, 1885)

Treloan, W. P., *Ludgate Hill: Past and Present* (Hazel, Watson & Viney: London, 1892)

Wheatley, H. B., *The Story of London* (London, 1909)

Whipp, D., *The Medieval Postern Gate by the Tower of London* (MOLA Museum of London Archaeology: 2006)

Wilson, H. W, *Temple Bar, the City Golgotha* (London, 1853)

Wood, M., *In Search of Shakespeare* (BBC Books: London, 2003)

Worsfold, T. Cato, *Staple Inn and its Story* (London, 1913)

Maps

Barron, C. M. and V. Harding, *A Map of Medieval London: The City, Westminster and Southwark* (The Historic Towns Trust: 2019)

Harding, V. and C. M. Barron (eds), *A Map of Tudor London: England's Capital City in 1520* (The Historic Towns Trust: 2018)

Londinium: A New Map and Guide to Roman London. MOLA (Museum of London Archaeology: 2011)

Map of Early Modern London, mapoflondon.uvic.ca/index.htm

Roque's Map of London (1746), locatinglondon.org

Websites

Archaeological work in the City of London 1907–91: colat.org.uk/assets/doc/links-archaeology-city-of-london.pdf

Bishop, B. A, A Keyhole through the Gateway (2006): academia.edu

'Conservation Areas of the City of London', Corporation of London (2001): cityoflondon.gov.uk

Diary of Samuel Pepys: pepysdiary.com

Historic England, 'London Wall': historicengland.org.uk

Rowsome, P., 'Roman and Medieval Defences North of Ludgate' (Summer 2014), London Archaeologist 3: colat.org.uk/assets/doc/rowsome-ludgate.pdf

Strype, J., A Survey of the Cities of London and Westminster (1720): dhi.ac.uk

Acknowledgements

Many miles were covered in researching this book. Not all places are open or easily accessible, so particular thanks go to those who allowed us to take photographs and those that gave permission to use their images, notably the Museum of London, WeWork, St Andrew Undershaft and St Botolph's Church, Aldersgate. Acknowledgements go to the staff at Amberley who supported the idea for this book, notably Angeline Wilcox. A huge appreciation goes to those who gave advice and encouragement to this project. The biggest thanks go to my good friend Rod Corston, who not only accompanied me around the City many times but also helped in photographing and editing the images, the cover image and producing the maps.